LIBRARIES OF MINNESOTA

LIBRARIES OF

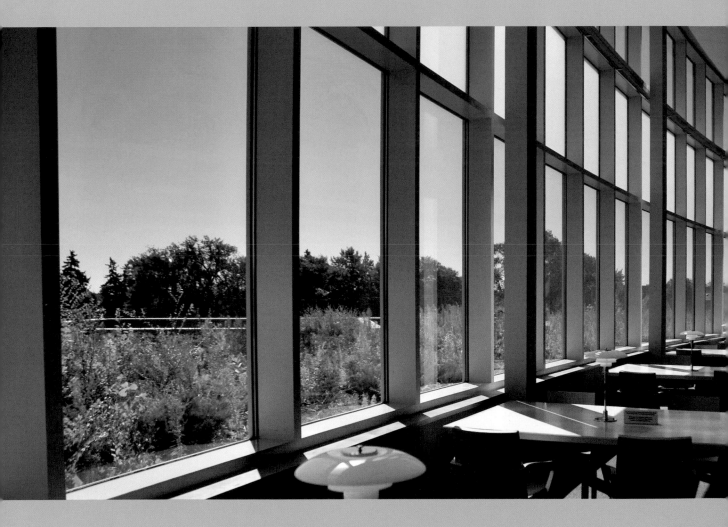

minnesota byways

MINNESOTA

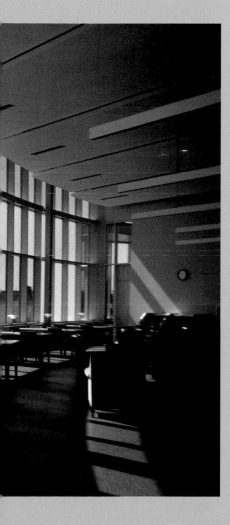

PHOTOGRAPHY BY
DOUG OHMAN

TEXT BY
WILL WEAVER

PETE HAUTMAN

JOHN COY

NANCY CARLSON

MARSHA WILSON CHALL

DAVID LaROCHELLE

KAO KALIA YANG

MINNESOTA HISTORICAL SOCIETY PRESS

This book is a cooperative project of the Council of Regional Public Library System Administrators and the Minnesota Historical Society Press. It was funded in part with money from the vote of the people of Minnesota on November 4, 2008, which dedicated funding to preserve Minnesota's arts and cultural heritage.

minnesota byways

Barns of Minnesota
Churches of Minnesota
Courthouses of Minnesota
Schoolhouses of Minnesota
Cabins of Minnesota

www.mhspress.org

The Minnesota Historical Society Press is a member of the Association of American University Presses.

Manufactured in China

Book and jacket design by Cathy Spengler Design

10 9 8 7 6 5 4 3 2 1

♾ The paper used in this publication meets the minimum requirements of the American National Standard for Information Sciences—Permanence for Printed Library Materials, ANSI Z39.48-1984.

International Standard Book Number
ISBN: 978-0-87351-824-6 (cloth)

Library of Congress Cataloging-in-Publication Data

Ohman, Doug, 1960–
Libraries of Minnesota / photography by Doug Ohman ; text by Will Weaver, Pete Hautman, John Coy, Nancy Carlson, Marsha Wilson Chall, David LaRochelle, and Kao Kalia Yang.
 pages cm. — (Minnesota byways)
Includes index.
ISBN 978-0-87351-824-6 (alk. paper)
1. Public libraries—Minnesota. 2. Library buildings—Minnesota—Pictorial works. I. Weaver, Will, 1950–
II. Title.

Z732.M75O48 2011
027.0776—dc22

 2010042714

Contents

LIBRARIES OF MINNESOTA

Will
Weaver

Library
Revolution

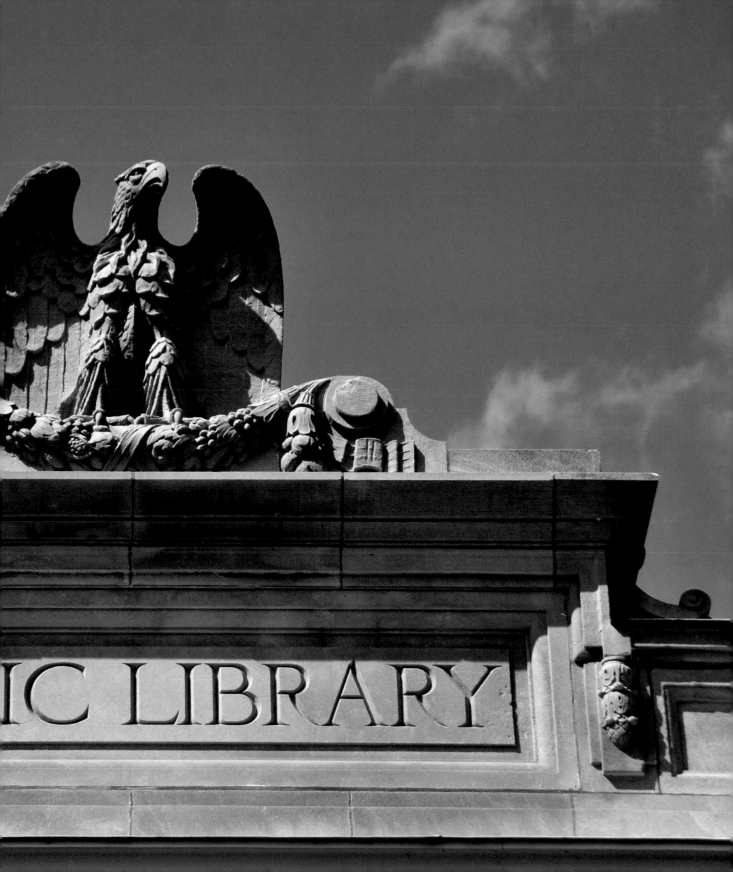

"Hey Ritchie, you can get a lieberry card, and they're free!'" So exclaims the cheerful but clueless Fonzie in the television series *Happy Days*. Played memorably by Henry Winkler, "the Fonz" waxes on about how "cool" a library card is: "You know, anybody can get one of these suckers." After the episode ("Hard Cover," season five) aired on television, library card registration increased 500 percent nationally in a matter of days. As Winkler would later say, "Who knew!"

Probably not even Benjamin Franklin, revered father of the American public library system, had he been around. His first "lending library," established in 1731, was at far remove from the Fonz's introduction to a public library. Franklin's vision was of a "social" library for his learned friends. Membership was by subscription, which meant buying stock in his Library Company of Philadelphia. As with a modern book club, the first social libraries were promoted by groups of the like-minded—in Franklin's case, a narrow stratum of the affluent and educated, who, of course, owned books.

Elitism was perhaps the largest obstacle in the development of a true public library system. Historically, from the Greeks through Old Europe and forward to the American colonies, ownership of books had always been by the ruling elite, including the clergy. Franklin owned over four thousand volumes; Jefferson's library was legendary. Paper was dear, printing an art, and leather covers laborious in their crafting, all of which made books expensive and therefore confined to the private libraries of the rich. After all, would not books be wasted upon the poor, who were largely illiterate anyway?

This way of thinking, however, was one that Franklin gradually came to disavow. As the American colonies inched toward independence, Franklin saw—if independence was to happen—a greater

PREVIOUS PAGES Buhl Public Library, St. Louis County (both photos)

and greater need for the sharing of ideas and information among "we the people." His personal enlightenment to the value of a wider literacy was no epiphany, no single flash of insight on a particular day. Rather, it was a natural evolution from his work as a printer, a writer, a pamphleteer, and a savvy businessman, all of which were informed by his efforts toward and belief in American independence. An emerging country required a new way of thinking—a higher moral vision than the corrupted monarchies and hidebound paradigms of Old Europe. As the street corners of pre-revolutionary America became increasingly dangerous places to mount a soapbox, printshops and bookstores—the predecessors of libraries—became the safe houses of democracy and free thinking.

Franklin's social library concept evolved in the late 1700s to the "circulating library." The first of these dates to 1762. Often housed in printshops or fledgling bookstores, circulating libraries allowed customers to rent books and return them. This arrangement was another step closer to the revolutionary idea of books free for the borrowing by anyone, that is, the true public (that great, unwashed population of which Fonzie happily claims membership). Franklin would later write, "libraries have improved the general conversation of the Ameri-

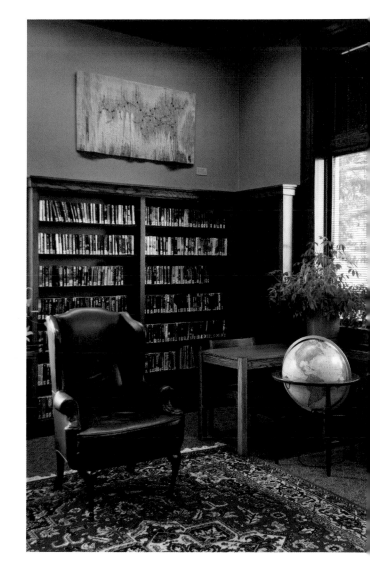

ABOVE Northfield Public Library, Rice County

cans, made the common tradesmen and farmers as intelligent as most gentlemen from other countries, and perhaps have contributed in some degree to the stand so generally made throughout the colonies in defence of their privileges."

Following the American Revolution came the rise of our public school system and with it the need for books for children. In the 1830s Horace Mann, legendary educator from Massachusetts, advocated for libraries within schools, their books to be purchased *by the taxpayers* for the benefit of public education, for the common good. This "revolutionary" concept marked the beginning of an American school library system with commonalities from state to state. However, Mann also posed this question: "after we educate our children, what will they have to read?" Built into Mann's query is recognition that children are future citizens and that adults need books, too. Gradually, legislators looked toward school district libraries to provide books for both children and adults, moving America closer to the true public library.

The great leap forward in the American library system came from a somewhat unlikely source: the "robber baron" Andrew Carnegie. The Scottish American entrepreneur and businessman amassed great wealth during the industrial revo-

lution through the steel and railroad industries, neither of which was known for enlightened treatment of its workers. Still, Carnegie believed books and reading to be an important part of his personal success, and, once his fortune was made, he turned to a philanthropy focused on books and education. The Carnegie Foundation built 1,689 libraries in the United States and hundreds more in other countries.

Carnegie libraries across America were designed in various classical styles, usually with columns in front and a formal entry. The architecture was serious and symbolic: a prominent entrance elevated by a flight of steps, and always a lamp or lantern at the door. The upward climb from street level, along with the light, symbolized progress and enlightenment. Any community could have such a library if it matched the Carnegie formula:

- demonstrate the need for a public library;
- provide the building site;
- annually provide ten percent of the cost of the library's construction to support its operation;
- and provide free service to all.

The latter aspect—free service to all—was no small matter: Carnegie's reinforcement of the

13

ideals of American democracy. The foundation's last library construction grant was awarded in 1923; in the decades following, and with support from public taxes, America's public library system grew to be the jewel in the crown of its democratic dream of equality among people as well as the responsibilities of citizenship.

My small town of Park Rapids (population 2,800) in northern Minnesota had its own Carnegie library. It was one of sixty-five built in Minnesota— nearly one per county. Constructed in 1908 at the cost of five thousand dollars, it had two white columns with swallows nests tucked underneath the cornices above and a flight of sharp-edged granite steps below. While the steps symbolized elevation to higher thoughts, that vision did not include

access for the handicapped; elevators and ramps would come many years later.

Inside "my" library was a churchlike stillness. Below high, ornate ceilings were tall, open stacks— shelves of books—with a rolling ladder on a greased track with little wheels below. Long tables with sturdy oak chairs were arranged squarely; each had a reading lamp. Arched windows with daylight muted by shade trees stood to the sides. Centrally positioned was the reference desk with Mrs. Kropp, the watchful head librarian, at her post, monitoring all corners of the great room.

Children's books were in a basement room, a matter perhaps also symbolic of the times. As a

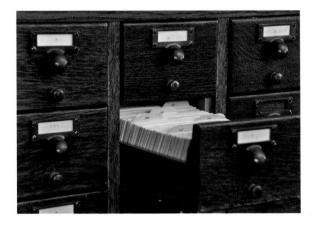

14

lad I spent many a happy Saturday summer morning there, looking at books, holding them, reading them, moving on to the next one, the literal clock ticking while my parents shopped or my father was at the feed mill getting oats and corn ground for our dairy cattle. The choice of books (no more than two) to check out and take home was agonizing. When I was big enough to trap gophers and range freely on my bicycle, I sometimes sneaked the full five miles into town and spent an hour or two at the library when I should have been running my trapline. I think Mrs. Kropp knew I was on the lam, those summer days, but she never blew the whistle. There was the faintest shine in her eyes when I mustered up courage to ask her a question about this book or that author, and, perhaps for my initiative, I was permitted up from the basement a year or two ahead of schedule. In the end, my little town's public library was pivotal in my love of books. It planted inside me some tiny seed that I, too, someday, somehow, might do something useful—even heroic—with my life.

Now, as an author, I find myself in libraries on a regular basis. I speak about books and writing. About the value of reading. About the crucial role of libraries in our national life. I have helped dedicate new libraries—for example, the fine, modern,

and very green library in Elk River, Minnesota; I have helped raise funds for older libraries in need. And while my message about libraries is consistent and while libraries have a generally common purpose, I have also found them to be as individual as people.

The smallest public library I have visited was in Bird Island, Minnesota (population 1,195). Housed in a corner of a city-owned building, Bird Island's library was six hundred square feet— about the size of a two-car garage; luckily it has recently found quarters about twice that size in a nearby public building. In far northwestern Minnesota, Hallock's public library, also squeezed into a multi-use city building, was narrow and long—a boxcar filled with bookshelves and people elbow-

15

to-elbow at computer stations. Hallock (population 1,196) did not have a formal public library until the 1970s. A local doctor had donated his personal collection of books to the city years earlier, and "some local ladies"—predecessors to the vitally important Friends of Libraries groups I have encountered across the state—organized themselves to press for space and staffing on behalf of a real library.

Which clearly describes the new, gleaming Minneapolis Central Library. Located on the Nicollet Mall, designed by world-famous architect Cesar Pelli, and offering nearly 100 percent access to over 2.4 million items (books, government documents, DVDs, and more), the building itself is a masterpiece of form and function. But put two feet inside, and all the fine design recedes in importance because the patrons—the people—are the library. In all their unending variety of age, ethnicity, and purpose, they have come to read, or play a piano in one of the music rooms, or listen to a CD, or gain access to the Internet, or curl up with a book.

Once, in a north Minneapolis branch of the Hennepin County Library system, I gave an evening reading. The library was busy, my face was prominent on posters, and the program was announced by loudspeaker; however, attendance was sparse. Only a handful of people sat for the event. Most of them knew my work and had come for the reading. A larger group of people paused at the rear, not willing to sit down but open to giving me a look, a listen, as we do for the person at the state fair hawking a "miracle peeler." A few minutes into my reading, some of the standers began to drift away to other parts of the library. As an author, I have never been insulted by such behavior because that is precisely why we come to libraries: we have things on our minds.

Following my reading that night, I took some time to wander about the library myself: to look at the new book acquisitions, to check out what people were reading, to come down from being "somebody." The patrons were a true mix of America in age, gender, race, and ethnicity. On their clothes I could smell food from their dinner tables, including curry, garlic, chilies, and spices I could not name; a whiff of urine; tobacco and patchouli. Some people read books or magazines, some wore headphones and mouthed words as they worked on their English, others did job searches online. In the middle of this hum and buzz of humanity I paused in a sudden, private thrill: I was inside the beating heart of American democracy. 🏛

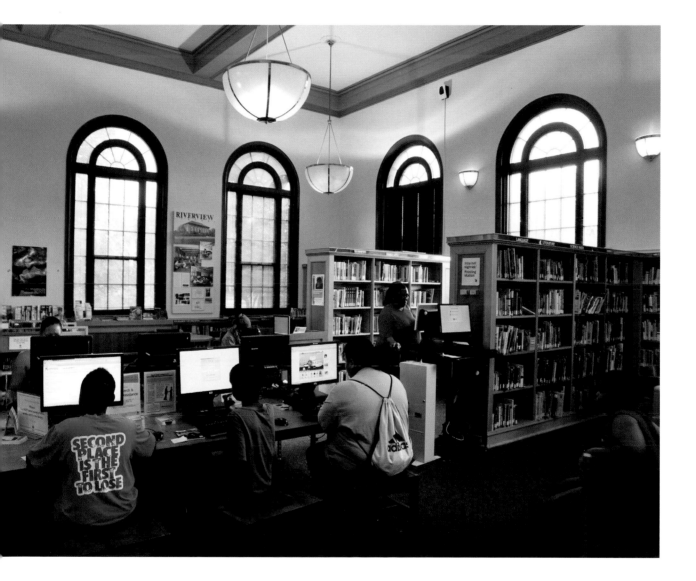

17

ABOVE Riverview Library, St. Paul, Ramsey County

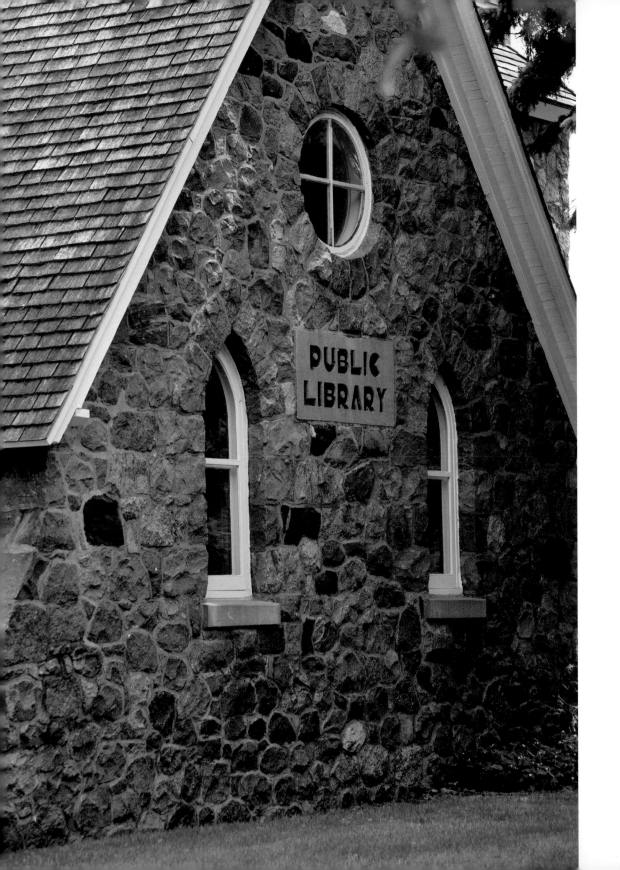

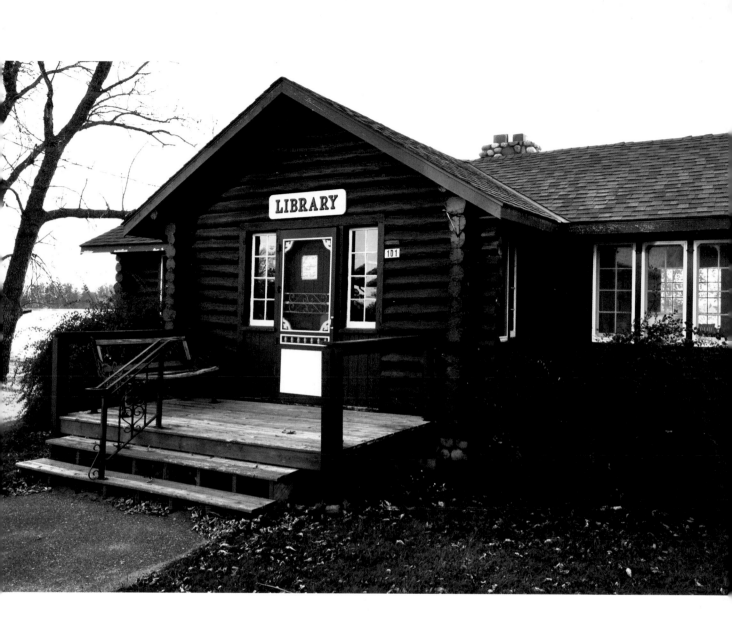

LEFT Perham Area Public Library, Otter Tail County

ABOVE Hackensack Volunteer Library, Cass County

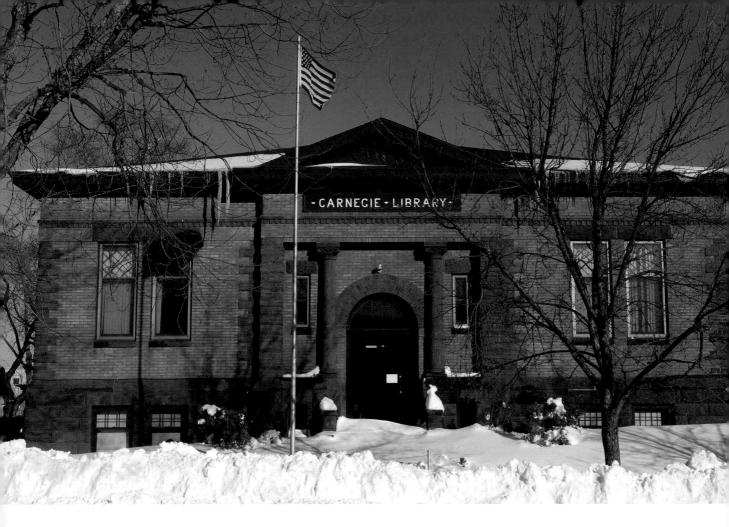

ABOVE Two Harbors Public Library, Lake County

BELOW Arlington Hills Library, St. Paul, Ramsey County

ABOVE Chisholm Public Library, St. Louis County

RIGHT Winona Public Library, Winona County

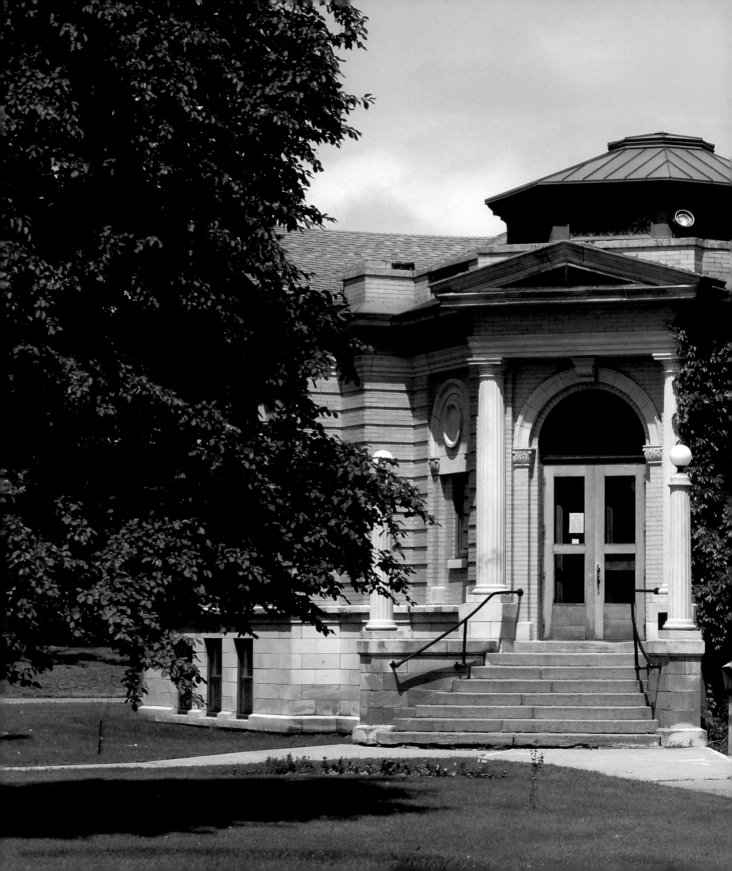

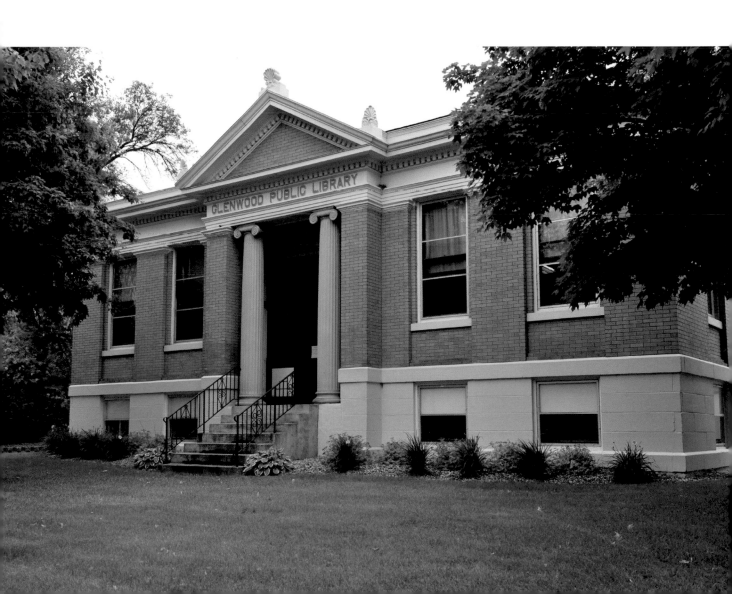

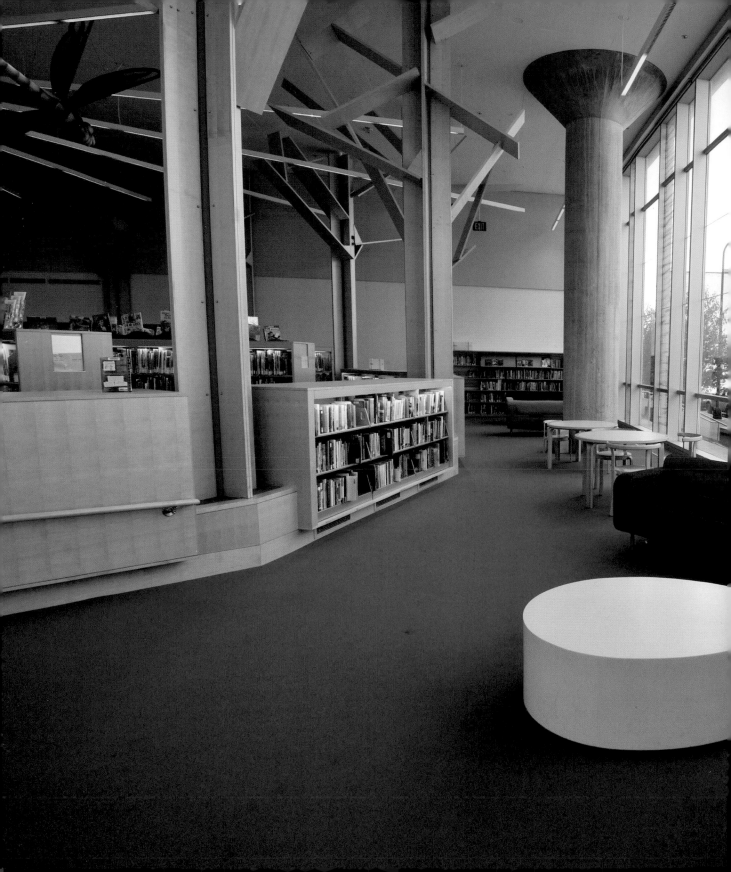

Pete
Hautman

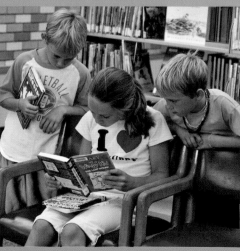

"Not Much
of a Reader"

Summers used to last a long, long time. Those first few heady days of NO SCHOOL always flew by quickly, but soon, as the days grew longer (both literally and figuratively), as childhood friendships and alliances were renegotiated (always, it seemed, painfully), as the physical and behavioral limitations of our neighborhood explorations solidified and became overly familiar . . . the whining would commence.

"Mooooom! I'm *borrrrred!*"

"Go play with Ricky."

"Ricky's up at his *caaaabin!*"

"Ride your bike someplace." I can imagine her thinking, *Anyplace!*

"I got a flat *tiiiiire!*"

"Fix it."

"I don't know *hooooow!*"

"Read a book."

"I read them *awwwwll!*"

"Take out the trash."

"*Mooooom!*"

Now, multiply that whine by seven. That was the number of kids in our family.

Not long ago I was hanging out with my mom and we were talking about those 1960s summers.

I asked her, "How did you do it? How did you cope with all us kids in the house?"

"Oh, it wasn't all that hard," she said. "I guess I just liked kids." She laughed. "Still do."

With a three-bedroom ranch house full of kids, no air conditioning, a husband who worked sixty hours a week, and a tight budget, Mom was overwhelmed with trying to keep us fed, clothed, safe, and occupied. Summer days in particular could be noisy, hot, and interminable.

When the weather was nice it wasn't so bad. We ran wild. Today's parents would be terrified to grant their children the unsupervised freedoms we were allowed. Most days the only rule was, "Be home by supper." And we were. The system worked, in part because we had little or no pocket money and home was our only source of food. Missing supper was not an option.

When the weather was not so nice, however— when it was too hot, too rainy, or too mosquito-y— we had to entertain ourselves at home. We had no computer, of course. No Xbox, no Wii, no smartphones. We did have a television—a small black-and-white portable with tinfoil flags on the antenna and a flickering screen that the vertical hold knob did little to correct—but TV was entertainment of

the last resort. There was nothing on during the day in the summer other than game shows and soap operas. Besides, a TV-watching child was considered available for chores: take out the trash, clean your room, pick up that mess, fold those towels, mow the lawn . . . the list was endless. We all became adept at chore-avoidance. Staying out of sight was a reliable strategy. Drawing or painting was another: to my mother, making art trumped making beds. A third chore-avoidance technique was to read. A kid with his or her nose in a book is a kid who is not fighting, yelling, throwing, breaking things, bleeding, whining, or otherwise creating a Mom-size headache. Reading a book was almost like being invisible—a good thing for all concerned.

Naturally there were days when we were utterly incapable of amusing ourselves, and often those days coincided with Mom developing a powerful urge to Get Out of the House. Leaving seven feral children home alone to self-destruct was not acceptable even back then, so she would pile all of us into her Ford Country Squire and take us someplace.

Her options were limited. What do you do with seven kids on a rainy or otherwise crappy summer day? There were no gigantic indoor shopping malls.

RIGHT **Northfield Public Library, Rice County**

Movies were expensive. The museums, though free, required a surfeit of vigilance: it would not do to have the four-year-old climbing into a sarcophagus for a closer look at the mummy while the six-year-old explored the surface of a Van Gogh with his grubby palms.

Which left us with a single free, safe, indoor, air-conditioned destination: the library.

My mother, in her own words, "was not much of a reader."

We always had books around the house. My dad's dusty collection of detective novels and Ernest Haycox westerns occupied a few shelves in the basement. His treasured bird books, several volumes on World War II, and an assortment of law books from college filled a smaller bookcase upstairs. For us kids, dozens upon dozens of Little

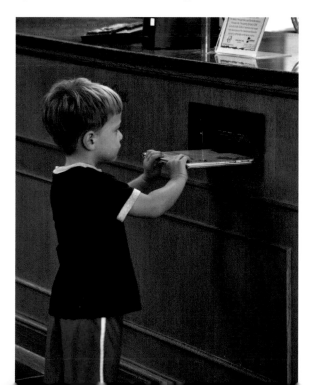

Golden Books in various states of deterioration were scattered throughout the house. We also had an assortment of the Hardy Boys and Nancy Drew volumes, the World Book Encyclopedia, and plenty of books about wild animals.

As for my mother, I don't remember her ever sitting down and reading a novel or a short story back then. She loved to look at art books, and she would sometimes consult self-help books, any one of which could have supported the subtitle *How to Stay Sane with Seven Screaming Children Underfoot.* She would read aloud to the younger kids, of course. And I remember her perusing a slim, mysterious volume with a dark blue cover titled *Understanding the Rhythm Method.* I thought it was about music.

Although Mom was not a big reader, she loved taking us to the library. At the library, we had to be quiet. At the library, she didn't have to keep an eye on every one of us at all times. At the library, we had to behave. The older kids were assigned to ride herd on the younger ones. Excessive noisiness or acrobatics would get us exiled to the benches outside.

Mom would settle in and page through oversize books with reproductions of works by Cezanne, Monet, Picasso, Matisse, Degas, and her other favorite painters while we kids searched the shelves for age-appropriate and fun-to-read materials. The selection back then was somewhat limited. There were no Hardy Boys or Nancy Drew books: those had to be borrowed, purchased at a garage sale, or received as Christmas gifts. The magazine selection was extremely paltry, and there were no comic books whatsoever. Still, the sheer number of books guaranteed that we would all find something, and we always left with armfuls of reading material.

We did not always go to the same library. Mom moved us from one library to another like a shepherd rotating sheep from one pasture to the next—usually from the St. Louis Park library to the Golden Valley library, and back again. "It's more fun that way," she told us.

By the fairly loose standards of our family, we were on our best behavior during these library visits, but by the standards of the librarians, I'm sure we were hell on wheels. Nevertheless, we were tolerated, and on those few occasions one of us was asked to wait outside, the banishment was temporary.

It did not occur to me until recently that our library hopping had less to do with Mom wanting to provide us with a wide and varied cultural experience and everything to do with her being ever

LEVEL 4 G–H

LEVEL 4 I–J

LEVEL 4 K–L

LEVEL 5 K–L

LEVEL 3 K–L

ABOVE Houston Public Library, Houston County

so slightly embarrassed to subject any one library to her brood two times in a row. I imagine that when we trooped into a library—a woman with a two-year-old attached to her hip, trailed by six self-propelled kids ages four and up—a shudder ran down the librarians' spines and echoed through the stacks.

I was not one of those kids who would ask a librarian what book I should read or how to find a certain book. I was too shy. Make that terrified. For one thing, librarians were all *old*. Which is to say, in their thirties or forties—or even in their *fifties*. And they had *rules*. Librarians were scarier back then. Or maybe I was shyer and more fearful. In any case, I avoided them as much as possible.

I remember one day—I must have been about nine—I came across a book with a picture of a beautiful Irish Setter on the cover. The book was called *Outlaw Red*, by Jim Kjelgaard. With a word like *outlaw* in the title, I knew it had to be exciting. It *was!* I read the first twenty pages right there in the library, and I finished it at home late that night.

On our next library visit I found more books by Jim Kjelgaard. That summer I devoured *Big Red, Irish Red,* and *The Duck-footed Hound.* I read his books about Australian aborigines and the Civil

War. I read about trappers and hunters and explorers and cavemen and pioneers. Kjelgaard's *Cochise, Chief of the Warriors* led me to track down every "Indian book" I could find, and the more books I read, the more I found. Any book with a dog, a horse, a spaceship, a gun, or a race car on the cover was fair game. *White Fang,* with its fierce-looking wolf-husky hybrid, introduced me to the works of Jack London. The Danny Dunn series, beginning with *Danny Dunn and the Anti-Gravity Paint,* sparked a lifelong love of science fiction. One book led to another. I groped my way happily from one adventure to the next.

For their part, the librarians probably saw me as a shy kid who liked to read and preferred to be

ABOVE Detroit Lakes Library, Becker County

RIGHT Perham Area Public Library, Otter Tail County

32

left to his own devices. They honored that desire. Librarians tend to be introverts themselves. They understand that sometimes the best way to attach a book to a boy is to leave him to find it on his own.

In 1961, a third library was added to our rotation: the new Central Library in downtown Minneapolis. It was a wonderland—more than just a big room filled with books. There was a planetarium, there were paintings and sculptures, there was a gift shop, and there were two enormous floors of books. It had an escalator! It felt more like an amusement park than a library, and at first we treated it as such. The library was so big that it was

possible to remain out of sight of the librarians—and Mom—long enough to get into all kinds of trouble. Which we did. Racing up the down escalator and down the up escalator was good for some solid entertainment, until we discovered that the Central Library had something our little suburban libraries did not: a uniformed security guard.

The security guard was even more terrifying than the librarians. He made me and my brother sit out in the lobby area with the scary homeless men for ten minutes—an eternity—before allowing us back inside to find our mother. The lesson stuck. No matter how big and exotic the Central Library was, it was still a library, not a playground. As a child, had I been asked what the library was for, I might have said that it was there to keep and protect books—as if by checking out a copy of *Big Red* I was subverting the library's true purpose. I thought I was getting away with something.

I now know that libraries are not simply big buildings full of books but something much greater. The library is there to protect and distribute information, yes, but it is also there to build and protect readers. Recently, I looked up the mission statement of the Hennepin County Library: "to nourish minds, transform lives and build community together."

That sounds about right.

ABOVE Bagley Library, Clearwater County

How many books did we lose, maim, destroy, or otherwise put an end to? I have no idea, but I'm certain that the money Mom spent on library fines was far less than she might otherwise have spent on movies and amusement parks. As a bonus, despite the fact that she was "not much of a reader," Mom accidentally-on-purpose raised a houseful of book lovers—and at least one writer.

Not long ago I called my mom and asked her what she was up to.

"I'm reading one of your books," she said.

"Which one?"

"The one with the water tower on the cover. I'm enjoying it."

Once all her kids moved out, Mom discovered she was a reader after all.

"What are you doing today?" she asked.

I told her I was spending the day with my nephews. "I planned to take them mushroom hunting," I said. "Only it looks like rain. I don't know what I'll do with those kids if it's raining."

She said, "Why don't you take them to the library?" 🏛

ABOVE Eden Prairie Library, Hennepin County

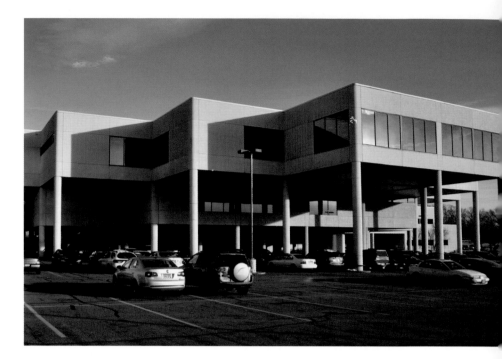

ABOVE Southdale Library, Hennepin County

BELOW Pelican Rapids Public Library, Otter Tail County

RIGHT Minneapolis Central Library, Hennepin County

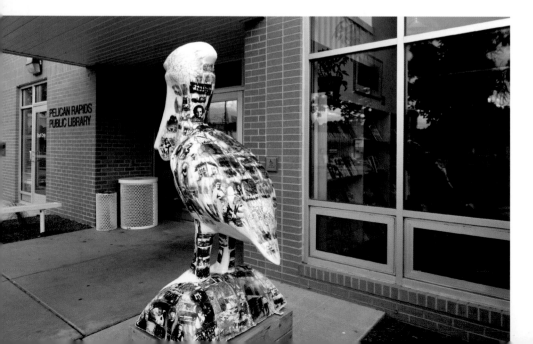

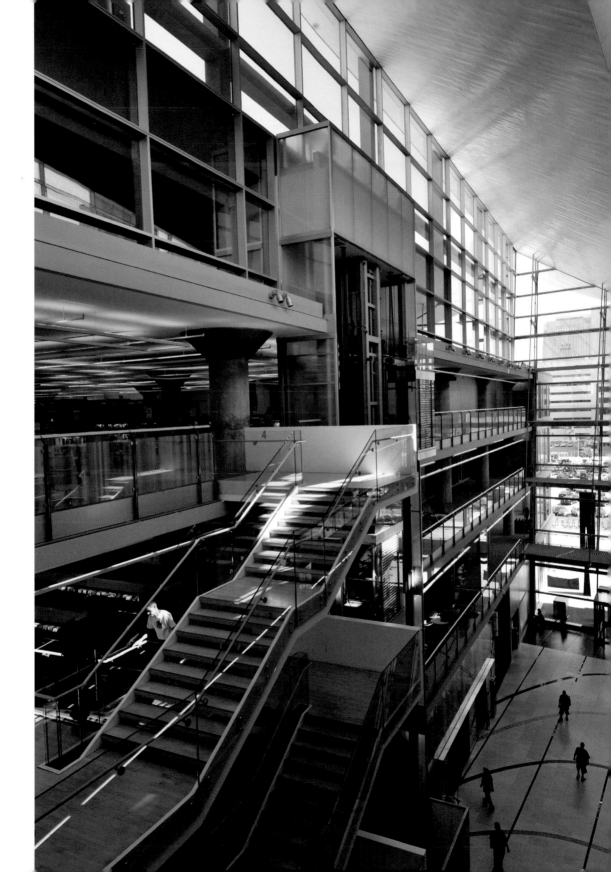

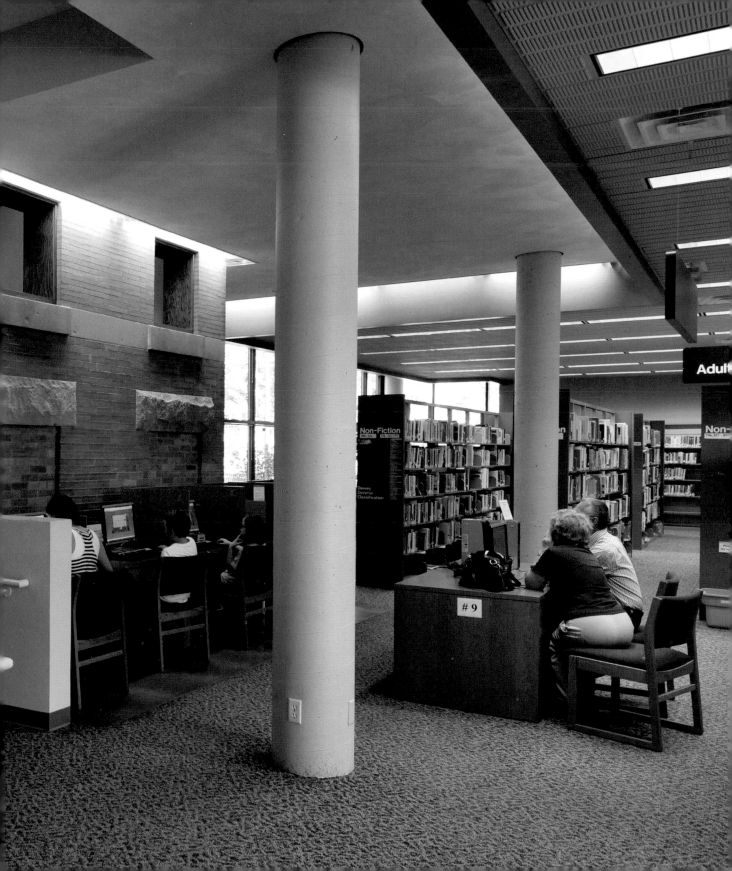

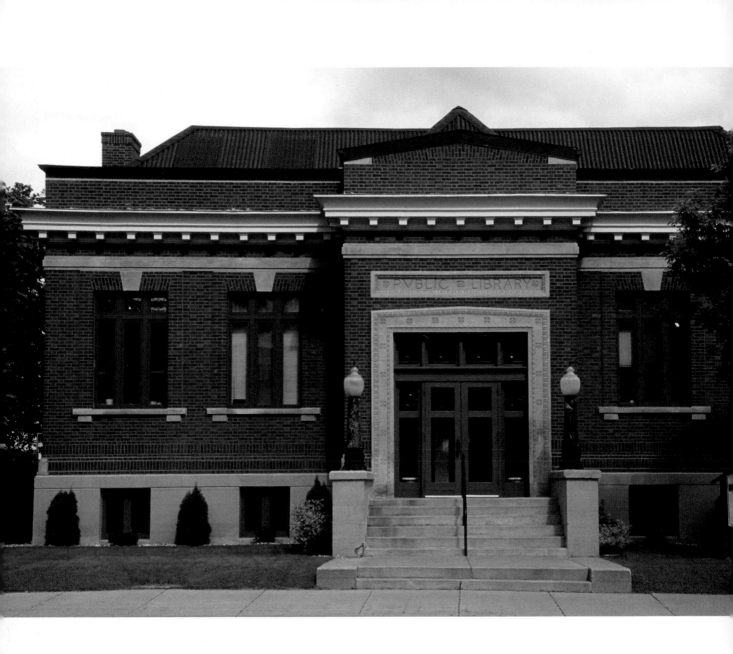

ABOVE Franklin Library, Minneapolis, Hennepin County

ABOVE Aitkin Public Library, Aitkin County

BELOW Redwood Falls Public Library, Redwood County

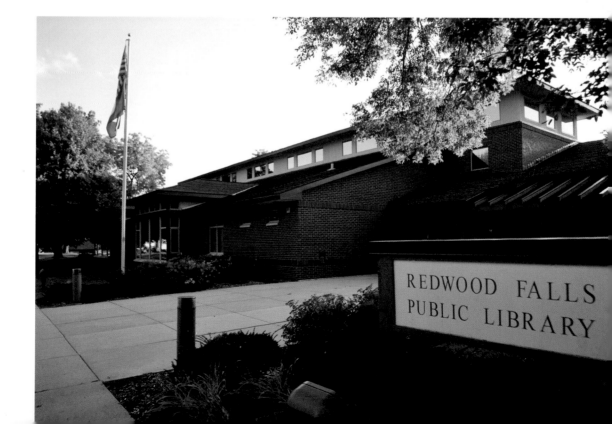

John
Coy

Inextricably
Connected

I am a writer because of libraries.

I grew up in a family that did not buy books. Instead, we went to the library where I chose what I wanted to read, defined my interests, and immersed myself in lives that were dramatically different from my own. Through libraries, I fell in love with books and the power words had to transport me.

My parents were raised in small Minnesota towns that did not have libraries—my father in Danvers in the western part of the state and my mother in Albany in Stearns County. When they discovered public libraries, they brought the zeal of converts with them. My mother loved that libraries were full of books that she wanted to read. My father loved this, too—but even more importantly, he loved that they were free.

My first library visits were to the bookmobile that came regularly to the University Grove neighborhood of Falcon Heights. In the late fifties and early sixties, University Grove, located near Larpenteur and Cleveland avenues just north of St. Paul's Midway district, contained rows of metal barracks that housed University of Minnesota married students and their families. For a boy fascinated with books and vehicles, the bookmobile was a dream come true. It was filled with interest-ing books like *Mike Mulligan and His Steam Shovel, The Day Daddy Stayed Home,* and *Go, Dog, Go!* Even more amazing, it brought the books to us. What greater job in the world could there be than to drive around with books and give them out to people who wanted them?

As a boy growing up in Eau Claire, Wisconsin, I made regular visits to the stately public library that had been built in 1904 with a grant from Andrew Carnegie. I treasured the freedom to pick out whatever I wanted, and I felt proud when I earned enough points in summer reading to select a book of my own to take home and keep. I chose

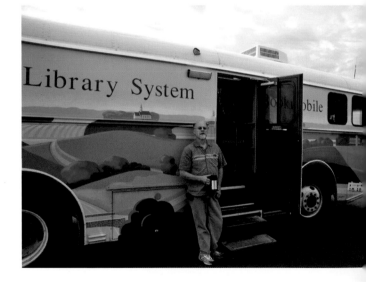

PREVIOUS PAGES Viking Bookmobile, Otter Tail County; Minneapolis Central Library, Hennepin County (inset)

ABOVE Viking Bookmobile, Otter Tail County

one called *Pitcher and Me* that I read many times and still treasure.

One day, the time came for me to climb the stairs to the adult section. I marveled at the tall stacks of books and the open space, but I also missed the familiar shelves and the friendly librarians who suggested titles for me. Nobody was going to offer that guidance up here, I thought, but I felt that I couldn't go back. I wasn't a child anymore.

Each year, when my family took a long, summer road trip, my mother checked out library books. When we stopped at a scenic spot and my father waited for the perfect light to take a picture, she read out loud. My brother, two sisters, and I sat and listened to *My Ántonia*, *True Grit*, or a biography of Theodore Roosevelt informed by the landscape in front of us. Libraries were part of these cross-country trips in another way, too. We spent memorable rainy afternoons in the public libraries of Estes Park, Colorado, Tillamook, Oregon, and Ketchikan, Alaska. We all spread out, selecting magazines, newspapers, or books, and no matter what town we were in, we felt at home.

Later, when I became a father, I passed on my love of reading to my daughter, and library visits

47

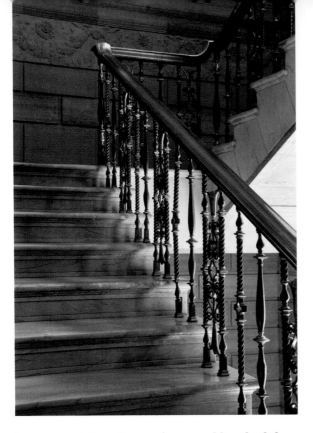

became an integral part of our weekly schedule. I rediscovered the children's section and was amazed how different many of the books were from those of my childhood. The art had changed dramatically, of course, but so had the text. A picture book called *Baseball Saved Us* provided a moving story of a Japanese American boy and his family in an internment camp during World War II. This topic would never have been covered by a picture book in my childhood. I became more and more interested in the form and the type of stories it was possible to tell.

As a dad in a one-car family who was at home during the day, I needed libraries that were on our bus route in St. Paul, and, fortunately, I had three to choose from. Downtown, the magnificent St. Paul Central Library, connected with the James J. Hill Reference Library on Rice Park, is one of the architectural jewels of the state. The large arched windows and marble walls are a testament to the values of Minnesotans who decided to build it in the early twentieth century. Inside, the old children's area was spacious and full of books, and it featured a wooden puppet theater where my daughter and I watched stories in another form.

We also went to another library downtown, one many people did not know about. The Skyway Library, a round, glass-enclosed booth located in Town Square, did not hold many books, but because the titles were chosen based on circulation, the percentage of excellent books was extremely high. The library was so small that it felt crowded on the rare occasions when more than three people were in it at the same time. More than anything, it reminded me of a bookmobile, a bookmobile that happened to be stationary. At that time, Town Square had a park on the top level, so after our lunch and time on the slide, the Skyway Library

ABOVE Central Library, St. Paul, Ramsey County

RIGHT St. Anthony Park Library, St. Paul, Ramsey County

48

was an ideal place to pick up books before catching the bus home.

We had another library choice if we took the bus west. The St. Anthony Park Public Library, a 1917 Carnegie library situated at the intersections of Como and Carter avenues in St. Paul, is a gorgeous building beloved by its patrons. In those days, before the addition of the children's room, the library was cramped, but we always found good books and a helpful staff.

I remember reading *Owl Moon* by Jane Yolen to my daughter and being enchanted. I remember laughing out loud together at *The Watsons Go to Birmingham—1963* by Christopher Paul Curtis. I remember being delighted by the distinctive voice of *The Great Gilly Hopkins* by Katherine Paterson. But I also remember reading some books together that I didn't enjoy and didn't think were particularly good. I wondered how they got published.

Later, when I inherited my grandfather's old Chevy Nova, we added the Roseville Public Library of the Ramsey County system to our rotation. There one evening, while I waited for my daughter to choose her books, I went over to the computer. I was bored, and for some reason I typed my own name into the author search. I wanted to see if anybody named John Coy had

written a book that was in the library. The answer flashed on the screen: zero books by this author. I was disappointed; I wanted something to come up. I decided right there, in that library, that I wanted to write a book.

That book became *Night Driving,* the story of a father and son driving west to the mountains. Based on my memories of the cross-country trips of my youth, the book was published in 1996 by Henry Holt, with beautiful illustrations by Peter McCarty. My mother was very excited, and she told all her friends that they could go to their local library and get the book. As an author, I had to gently remind her that it was also okay if some people went to a bookstore and bought a copy.

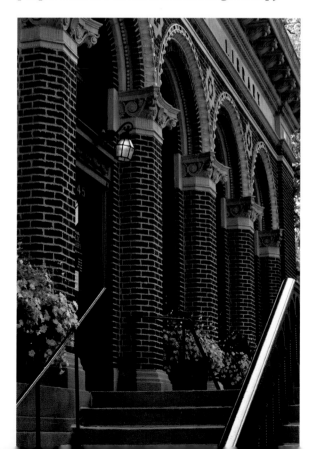

49

Nothing made being an author more real to me than walking into a library and seeing *Night Driving* on the shelf. When I found a copy, I took the liberty of setting it face out so somebody else could easily see it and check it out. A librarian who heard how the book began printed a page to show me the record of a book by an author with my name. Another person told me that the perfect spot for *Night Driving* would be a bookmobile, and I was thrilled the first time I saw it in one. Knowing that my book about driving was being driven around made the circle complete.

Today, my primary library is the St. Anthony Park branch. Every time I go there, I'm struck by how beautiful it is. The triangular lawn and gardens in front of the rectangular building present a celebration of symmetry, and the addition in 1999 of the round children's room behind the old library retains the architectural integrity while providing space for a first-rate collection of children's literature. Inside, light pours through the arched windows as librarians help people find the information they need.

I reserve books at this library, I browse the shelves, and every two weeks I show up for work with my writing group. Since 1991, we have met to read and critique each other's stories at three

ABOVE Pierre Bottineau Library, Minneapolis, Hennepin County

RIGHT Minneapolis Central Library, Hennepin County

different libraries: Hosmer in Minneapolis and Merriam Park and St. Anthony Park in St. Paul. In each of these, librarians have generously allowed us to use the public meeting rooms downstairs— a fine metaphor for the writing work of dropping down into the subconscious for an image or an inspiration.

Over the years, I've been fortunate to work with many excellent librarians. I once heard Alice Neve give a talk to a group of elementary school students at the St. Paul Central Library. She encouraged them to sign up for library cards and to visit regularly. Then she pointed around to the books on the shelves. "My job is not to make sure that these books stay here and are nice and neat,"

she said. "My job is to get these books into your homes." I needed Alice to be this direct to understand that the most successful libraries are not the ones that are full of books but the ones that do the best job of lending those books.

Major changes are occurring in the ways we read, the ways we tell stories, and the ways we gather information. I believe that public libraries are more important now than ever. They provide access to information for people who do not have it on their own. They provide a public symbol of the equal opportunity we espouse. And they provide a place and means for everyone who has a dream of what he or she wants to achieve.

My life has been inextricably connected with libraries since I was a boy going to the bookmobile to pick out *And to Think That I Saw It on Mulberry Street* and *One Fish, Two Fish, Red Fish, Blue Fish.* I have been fortunate to live in communities that built beautiful libraries, developed rich collections, and provided the funding to keep them open. Each generation makes such decisions about what it values and leaves behind. It is up to all of us to make sure that the library opportunities we enjoy are there for the generations to come. 🏛

51

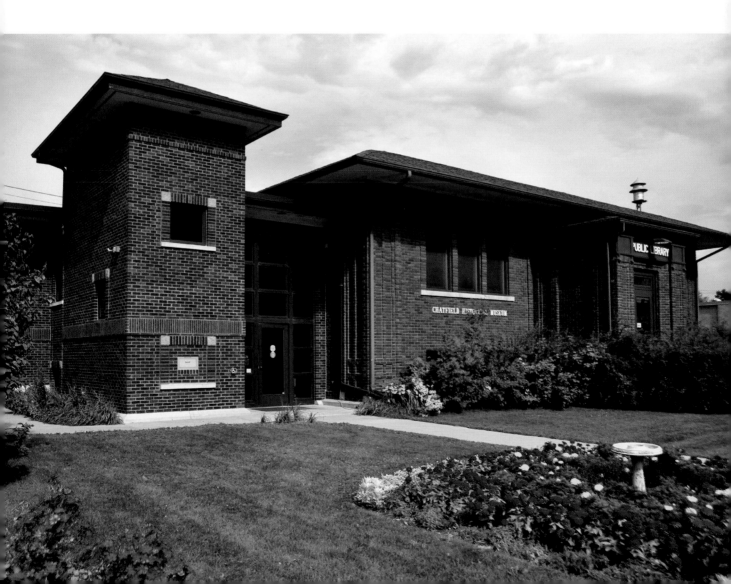

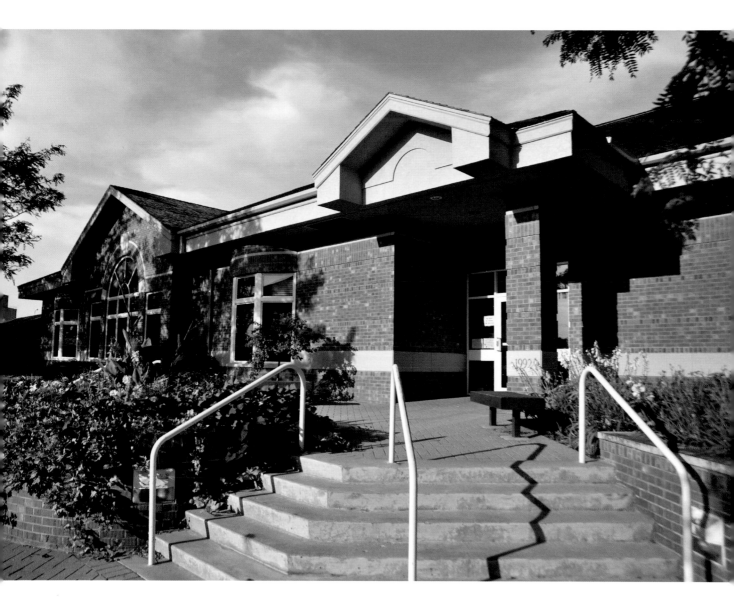

ABOVE Springfield Public Library, Brown County

54

ABOVE Galaxie Library, Apple Valley, Dakota County

BELOW St. Anthony Park Library, St. Paul, Ramsey County

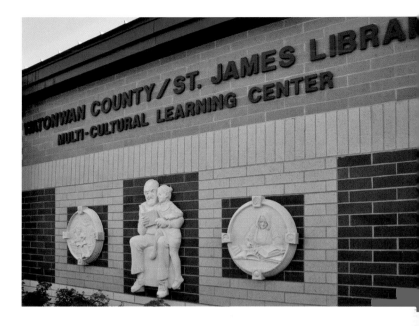

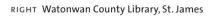

RIGHT Watonwan County Library, St. James

BELOW Rondo Community Outreach Library,
St. Paul, Ramsey County

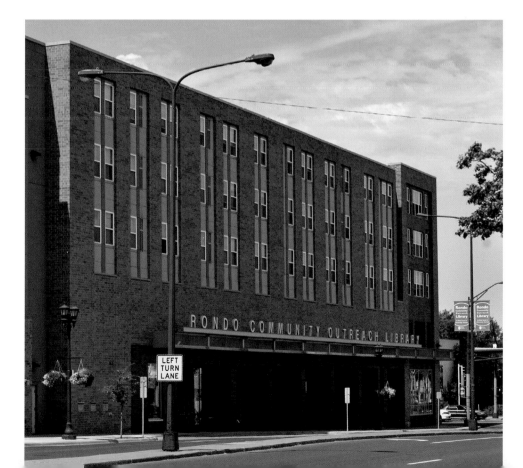

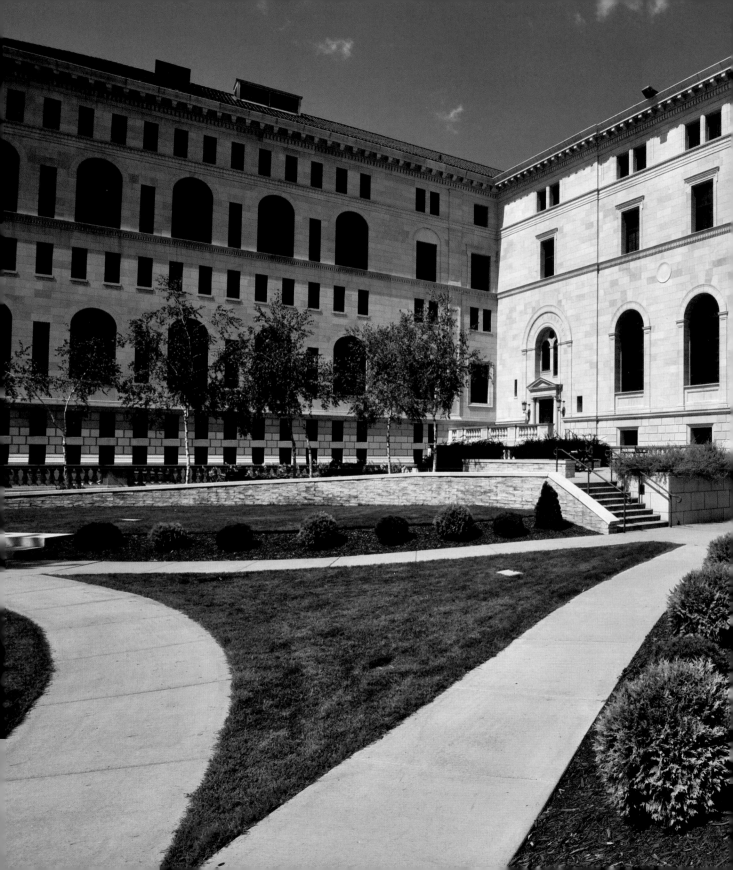

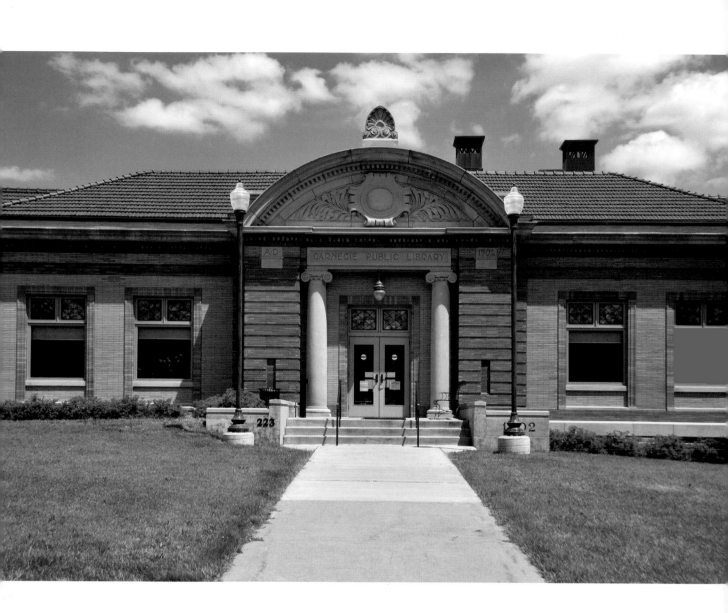

PREVIOUS PAGES Central Library, St. Paul, Ramsey County

ABOVE Stillwater Public Library, Washington County

RIGHT Northfield Public Library, Rice County

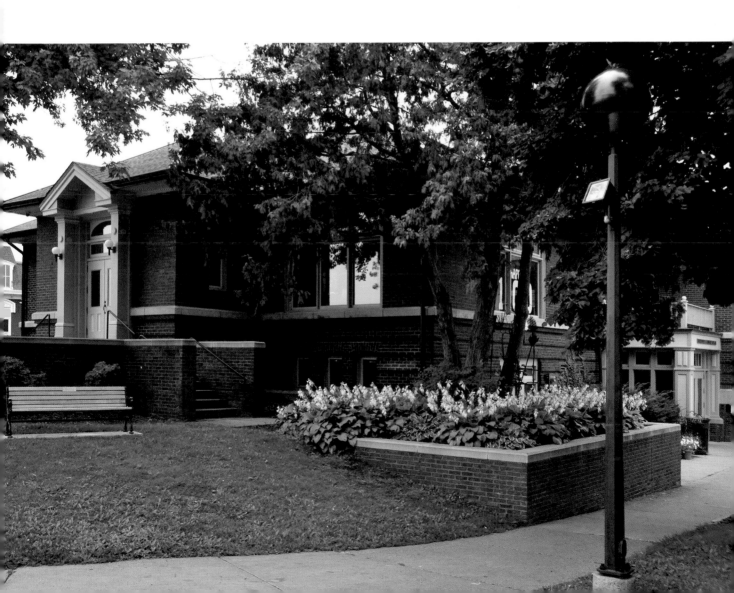

Nancy
Carlson

🏛

Summer
Reading

I still have my reading chart from 1963, taped into an old scrapbook. On its cover, a clown holding six colored balloons climbs over a book labeled "Summer Reading Carnival." My name, Nancy Lee Carlson, is written underneath the artwork. The chart holds an envelope with slips of paper listing all the books I read that summer. Taped to another scrapbook page is a newspaper photo, taken from behind, of a group of kids watching a puppet show on the lawn of the Edina Public Library. I know which one is me because my hair is a mess. It was the final day of

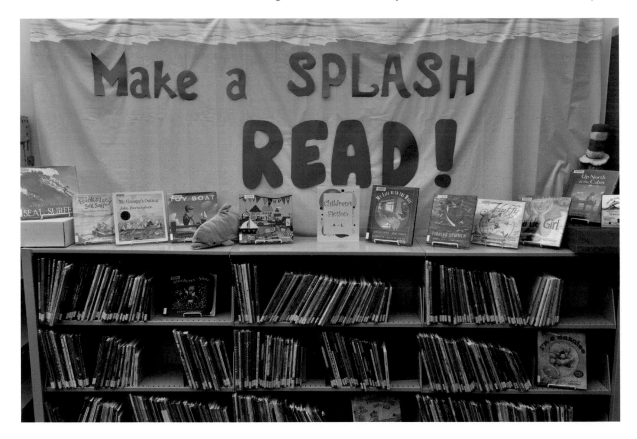

62

PREVIOUS PAGES Ada Library, Norman County; Pierre Bottineau Library, Minneapolis, Hennepin County (inset)

ABOVE Fosston Library, Polk County

the Summer Reading Carnival, and after the puppet show we got ice cream. I remember that day and that summer as if it were yesterday. That was the summer I discovered the public library and became a lifelong reader.

Earlier that spring, a librarian with red hair spoke to my third grade class about the Summer Reading Carnival up at the public library. She told us if we joined the program and read six books we might win a prize. Prize? I loved prizes! Whatever this summer reading program was, I was *in*. After all, I had just read my first chapter book, a biography of Babe Ruth. (I was a huge baseball fan then and thought it totally unfair that girls could not be bat boys.) I carried that book around with me for weeks just to show off. Look, kindergartners and first and second graders, and take *that*, all you teachers who almost gave up on me: I am now a reader!

On the first day of summer vacation, I jumped on my bike and headed to the library. I had never been in it before because we had lots of books at home. My mother bought us Golden Books at the grocery store, and we checked out books from the school and church libraries. But I knew just where the library was because my school bus drove by it every day. I was almost ten, and I knew my way

around pretty well. After all, I had been riding my bike to get my allergy shots for a year already. I also rode to the candy shop on Saturdays with my best friend, Laurie. I was old enough to stay out until dark, playing tag and night games with the huge gang of neighborhood kids. So off I went, riding my bike down France Avenue. I turned left on Fiftieth Street, past a music shop and a Fanny Farmer chocolates store. Yum! I rode past Clancy's, which was a real temptation because the drug store had the coolest toy store in the basement. Maybe later: for now, I was going to join the Summer Reading Carnival.

I parked my bike and ran up a path through mature oak and apple trees to an old Tudor farmhouse, the Edina Public Library, circa 1963. I

63

walked in the side door and immediately fell in love. The library was cool inside because of the big trees shading it. My neighborhood didn't have big trees yet because all the houses were brand new, built on old gravel pits and farms. Without the trees, the Southdale mall, also brand new, was visible from our front yard. And our house was hot all summer long.

There must have been a million books. They were everywhere—on the porch, up the stairs, even in the kitchen. The smell of woodwork mixed up with the scent of books was wonderful. I always thought stained-glass windows were only in

church, but there was one in the library, and on sunny days it threw bits of color on the books. The floor creaked as kids and adults made their selections. I signed up for the Summer Reading Carnival and got a library card: finally, a use for my new, genuine leather wallet. I looked around. The reading possibilities were endless. Where would I start?

"At the children's section, right here. Where I can see you," said the librarian.

Wow, she could read my mind.

I learned right away that the librarians ran a tight ship. Kind of like at home, where the living room was definitely out of bounds, so was the adult section at the library. You just did not wander over there, *ever*. There were other rules. If you came in fresh from a baseball game or a dirtball fight at the park, you had to wash your hands. No books were checked out to dirty children. All summer, my friends and I wore our swimsuits under our clothes almost every day. Hey, you had to be prepared: there could be a sprinkler to run through or a quick trip to the city pool. But if you came into the library with a wet suit, you were sent out into the yard to dry. You also had to whisper really, really, really quietly or you heard *Ssshhhhhhhhhhhhhhh- ssshhhhhhhhhhh- SSSHHHHHHSHHHHHHHHHHH.*

64

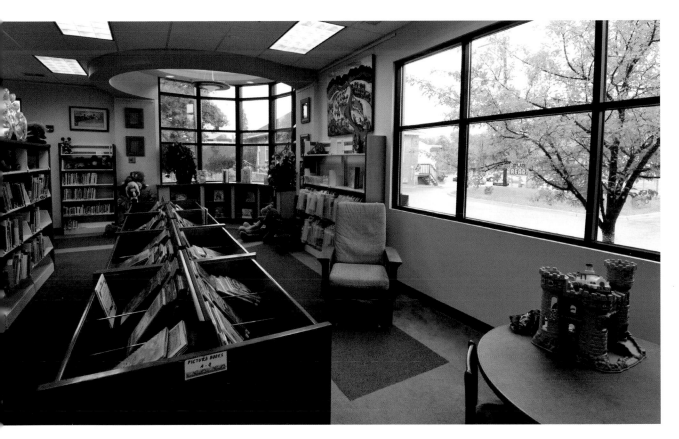

Now, I have to confess that I "accidentally" cheated a little, but I really wanted to get a jump on that prize. The first book I read for the carnival was *The Biography of Babe Ruth*—for the second time. I liked it so much that I had to reread it. Plus, there was that prize to win.

All summer long I rode up to the library, and if I was clean, dry, and quiet, the children's book section was all mine. I also discovered that the library was a great place to use my imagination. Sometimes I imagined I was a zillionaire's daughter and my father bought me my very own library

and all the books were mine. Sometimes I was an orphan girl living in the library alone with my own secret garden out back. Sometimes I was a pioneer girl grabbing an apple on my way up to the library from my sod house. Sometimes I was a girl named Betsy with a best friend named Tacy. But no matter who I imagined I was, I always looked just like Hayley Mills.

By the end of the summer, the library really *was* like home. I knew every nook and cranny. The apples were ripe when we all gathered on the lawn to celebrate our summer reading. There was a puppet show, and some other kid who I am pretty sure hadn't read all six books won the prize. But we had ice cream—and I was hooked on reading.

The next few summers, I signed up for the reading program. One year, after reading *My Side of the Mountain,* I spent hours trying to build a fort in the wilderness of my suburban backyard. The world was changing, and so was I. President Kennedy was shot, we were fighting a war in Vietnam, and Edina was growing. I stopped pretending the library was my very own house the summer I saw in the music shop a poster of four guys from England called the Beatles. Now I imagined I would marry George. Edina outgrew that library in the late sixties, and it was bulldozed to make room for a parking lot. By the time they built a brand-new library up the street, I had decided to be a hippie. At the new library, I discovered Richard Brautigan and Kurt Vonnegut (and imagined I was at Woodstock).

Right after the puppet show on that long-ago summer day, I remember lying down on the lawn with my hands behind my head, looking (I was pretty sure) just like Hayley Mills. I stared up at those apple trees. The library behind me was filled with books just waiting to be read. Later I might ride to the pool. Maybe I would play outside until dark. Or I just might go home and read my new library book. 🏛

ABOVE Austin Public Library, Mower County

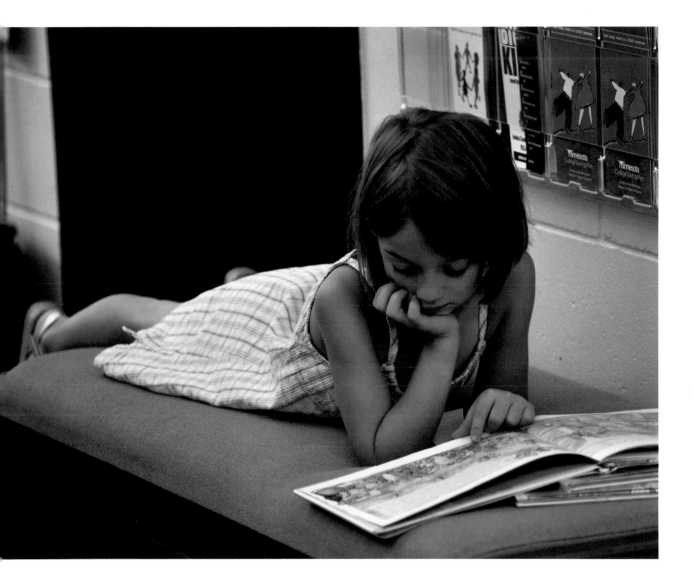

ABOVE Columbia Heights Public Library, Anoka County

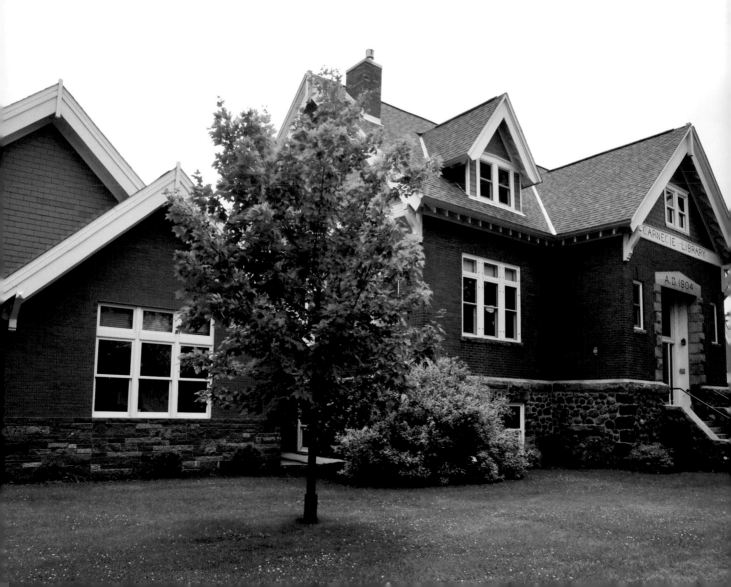

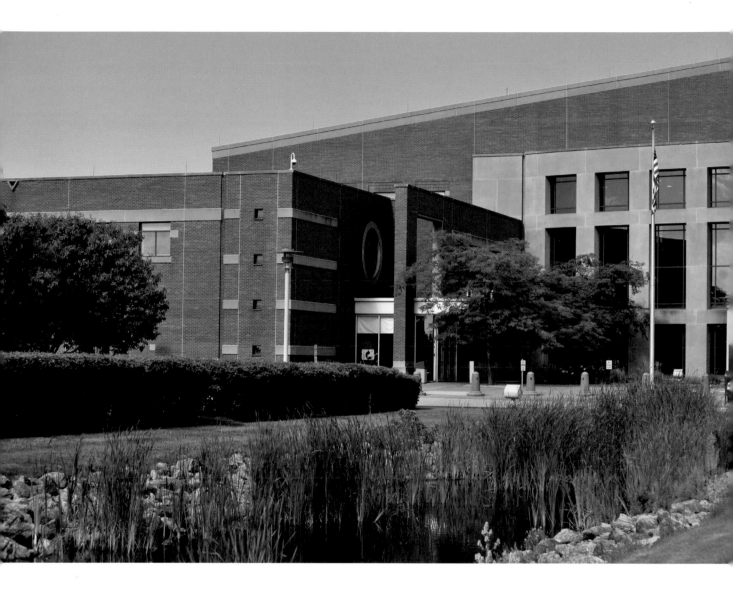

ABOVE Galaxie Library, Apple Valley, Dakota County

ABOVE Ortonville Public Library, Big Stone County

BELOW Crosslake Area Library, Crow Wing County

RIGHT St. Bonifacius Library, Hennepin County

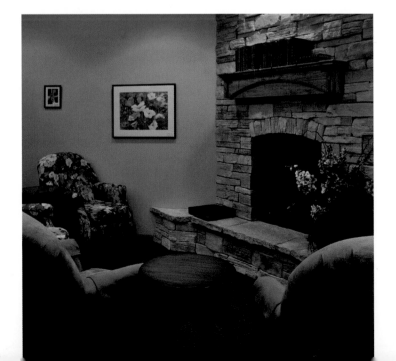

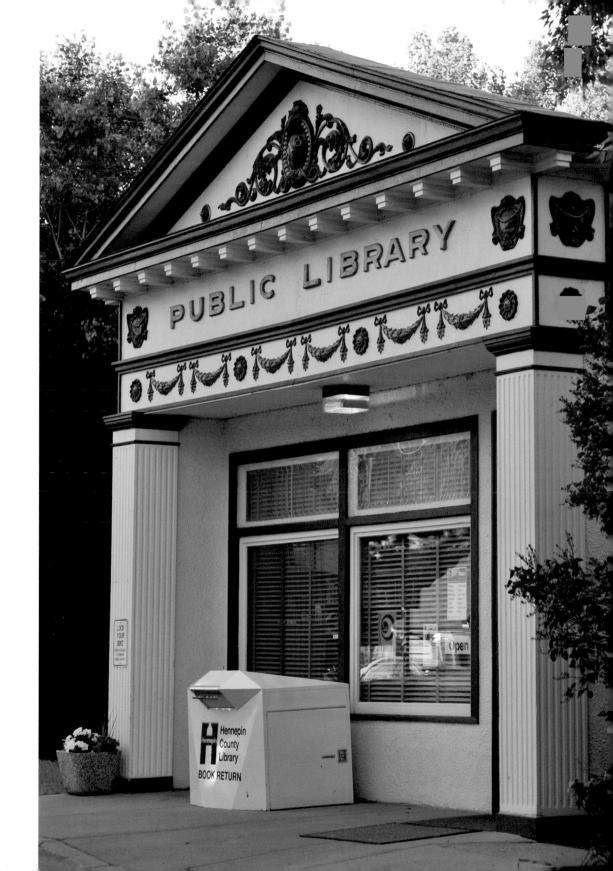

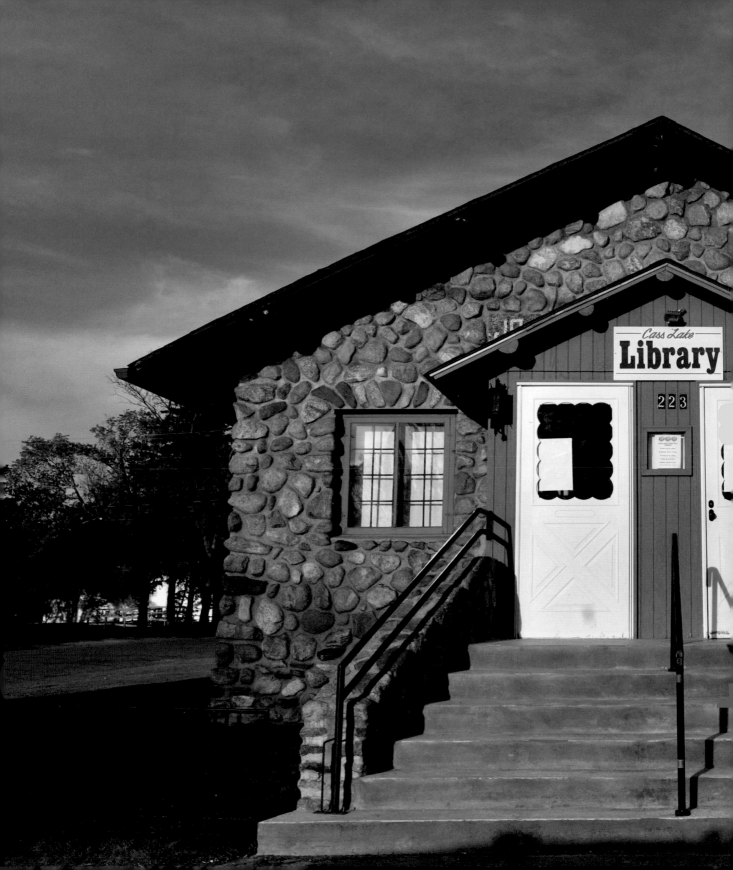

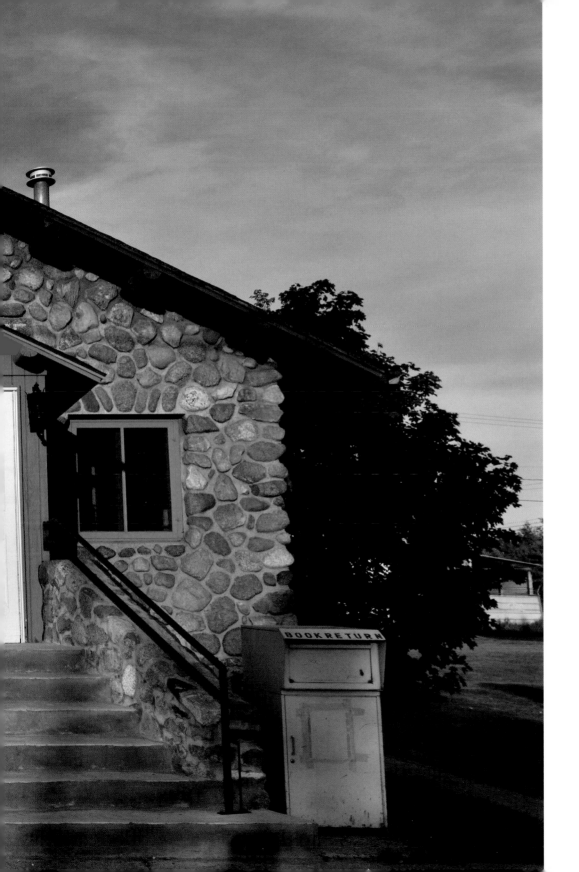

73

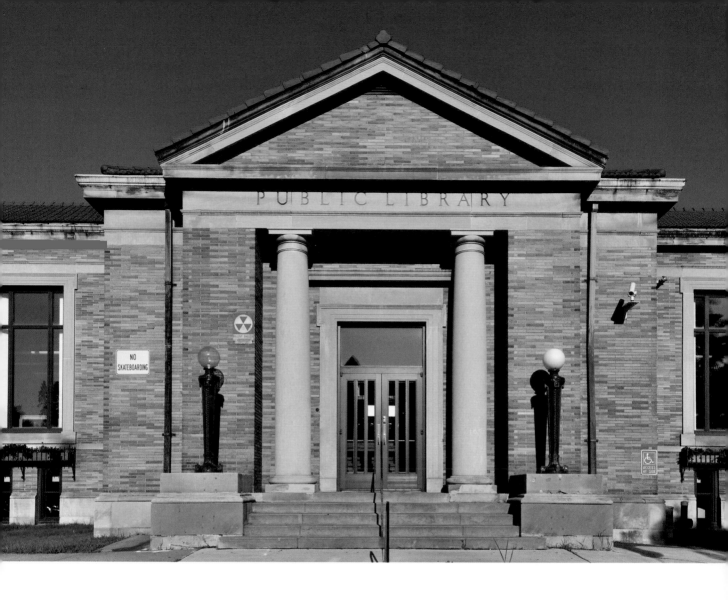

PREVIOUS PAGES Cass Lake Community Library, Cass County

ABOVE Virginia Public Library, St. Louis County

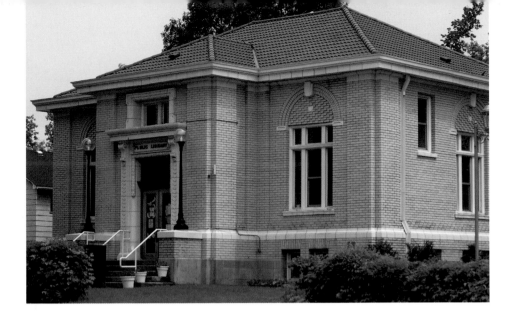

ABOVE Mountain Iron Public Library,
St. Louis County

LEFT Madison Public Library,
Lac qui Parle County

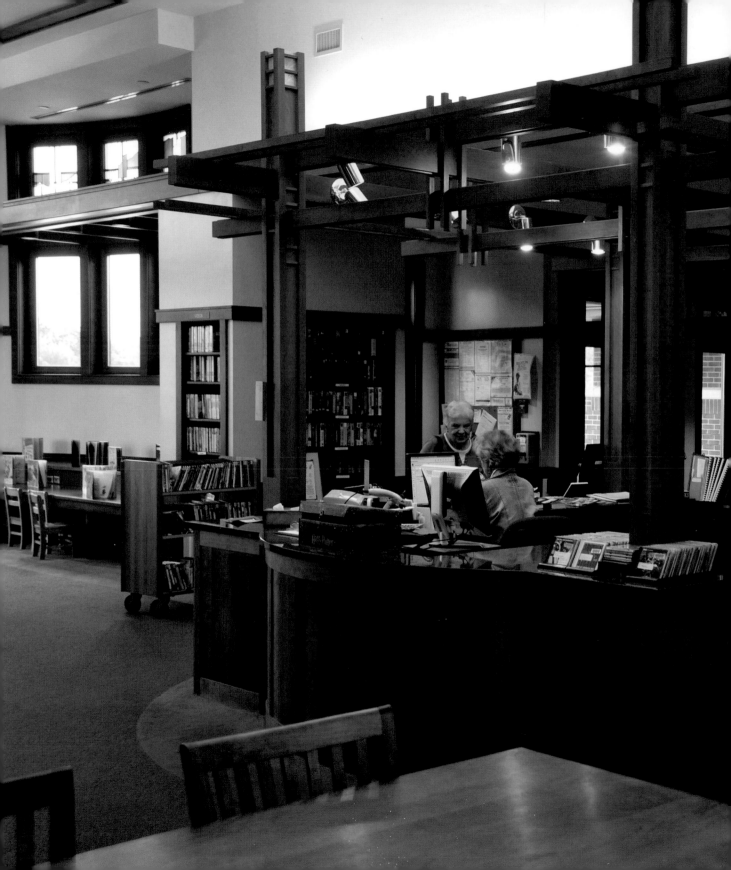

Marsha
Wilson
Chall

Borrowed
Time

Saturday mornings then, you rode in the backseat of the car unbuckled and unbridled, Dad behind the wheel and Mom in the front passenger position. Our Ford was orange and white, a Dreamsicle on wheels, cool in these still-early hours. Cooler still when I rolled down my window. I had the backseat to myself but always seemed to sit behind Mom, studying the way the smoke from her cigarette curled around the sprayed and spun galaxy of hair that would soon implode at Jackie Ann's Beauty Shop. Breck girl though I hoped to be, I would never sleep every night from Saturday to Saturday with my head wrapped in toilet paper. How could she? And I would never smoke, for cripes sake, and I would never sing every song on the radio out loud, even when I did know the words. What I would do and did do on Saturday morning was drop off Mom and ride with Dad down Victory Memorial Drive to the old Camden Library, officially known as the Webber Park branch, in Minneapolis.

I needed to. Our late-fifties Brooklyn Center rambler did not boast a paneled library, the kind I'd seen on TV in Ward Cleaver's home office or in Victorian mansion movie sets, but, then again, my father was neither an actor nor a wealthy Englishman. And I was not Theodore ("Beaver" to most) Cleaver or Mary Lennox. Our home library was, shall we say, condensed, like the red and white cans of soup and Reader's Digest Books I consumed at Grandma's. Sometimes you got what they said you'd get: a condensed truth. But not always. For example, our rambler didn't even ramble.

Ms. Dickinson did tell all the truth. Lands did await me at the library and its sweeping grounds. The USS *Dreamsicle* delivered me there to set sail on a pond draped in willows, still as a looking glass in wonderland. I could be Robinson or Alice or a conquistador hungry to pillage the plunder of the Mission Style building. Red roof tiles hot as salsa, white stucco cool as cream, it rumbaed and rested on the verdant lawn of Webber Park from 1910 to 1979 adjacent the John Deere Webber Baths, names eponymous of a boy who died in 1907 at the same age as I, nearly ten years old. His parents, Charles Deere Webber and Mary Harris Webber,

PREVIOUS PAGES Warroad Public Library, Roseau County; Minneapolis Central Library, Hennepin County (inset)

RIGHT Janesville Free Public Library, Waseca County

left the legacy of two swimming pools, playgrounds, and a Memorial Field House, the second floor added only if operated continuously as a public library by the Minneapolis Library Board. All this in memory of their only child, John Deere Webber, great-grandson of the inventor of the yellow and green tractor that bears his name. In 1954, the library expanded to the entire building in full service to North Minneapolis and her sister suburbs.

Welcome, friends. Cross the shaded portico. Enter and behold.

In the stillness, my eyes change to library eyes, and my ears to library ears. Vision adjusts to the indoor light and hearing to the white noise of silence. But sometimes my library ears cannot tune out the words on the page talking inside my head, and sometimes I am sure I hear the words read in other people's heads. The library is anything but quiet until those words melt away, the red roof and white stucco recede, and the world of story rises from the deep, lands away.

"All around the wagon there was nothing but empty and silent space. Laura didn't like it. But Pa was on the wagon seat and Jack was under the wagon; she knew that nothing could hurt her while Pa and Jack were there." LAURA INGALLS WILDER, *LITTLE HOUSE ON THE PRAIRIE*

Cue reader: It's a big, scary world out there. Drive a sturdy wagon. Keep a dog. Wear a sunbonnet. Or, like Laura, throw it off. Brown your face. Flaunt your hair in the prairie wind. Go, Half-pint, go! Do nice, but be naughty—at least a little, sometimes.

Tell us that you want to slap your big sister and keep the necklace for yourself. Save your compassion for the brindled bulldog Jack and your ponies and your cow.

We pioneers fashioned a corner of the basement as the Little House with a card table, folding chairs, blankets, and an appliance-box stable surrounded by prairie yellow linoleum. I played Laura because, like her, I was short and brunette, though a year older than my taller blond friend, Jeanne, often cast as Mary, the big sister. As Laura, I also

ABOVE Mahnomen Library, Mahnomen County

got the better dialogue: "Now, Mary, don't mind me hauling water from the well that Pa and I dug while you practiced your stitching." I might then ford a rising creek, save Ma from the indigenous people, survive the fever 'n' ague, and grow up to be a handsome woman swollen with child in all the right places. This was exhausting. And most amazing that the author of these adventures not only lived them but still had the stamina to write about them in her advanced years.

No doubt Laura Ingalls would have earned every badge in my Intermediate Girl Scout Handbook and sewn them on the forest green sash

herself. Before breakfast. Mine displayed a measly nine embroidered circles, none attached by me and one half owed to her. I fulfilled the requirements for the "Magic Carpet" reading badge by having a library card, knowing the responsibilities of library usage, and reading two books about an American heroine. Thank you, Laura Ingalls Wilder. If only I had such a life as yours, I would write it down. Someone might check it out some Saturday morning.

"I do not want any correction made in the paper now, that isn't what I want, but if you can tell the gentleman who wrote this article that John did not die by drowning, he died from sickness and in bed, I shall much appreciate it." CHARLES C. WEBBER, IN A LETTER TO THE *MINNEAPOLIS TRIBUNE*, 1936

At nine years and eleven months, John Deere Webber died from epidemic meningitis, not by drowning. Nearly thirty years hence, his father set the record straight. For three decades, the belief that this boy drowned could have seemed a cruel irony to his parents, who gifted swimming pools to the community. Or did the public perceive the baths as a fitting tribute to a child who died doing what he loved or, rather, as a cautionary reminder to parents everywhere? *Don't look away, not even for an instant.*

81

Surely the Webbers did not. Their son did not die of neglect or accident or meanness. He died from sickness and in bed and you could tell the gentleman who wrote the article that even at only nine years of age, John Deere Webber knew a lot of truth already, that velveteen rabbits become real and boys, kings. He read it in books and would probably have wanted to read every book ever written to learn all the truth. That kind of person needs a library. I'm glad they gave him one. And in grand style at that, for a very long time.

Razed in 1979 for a new swimming pool, the library of red tiles and creamy stucco walls stands now only in memory. But the Webber Park branch survives in a contemporary-style brick building, opened in 1980, only a few blocks from the original site. Still part of Webber Park, it's busy, in fact crowded, the Saturday I visit in 2010, forty-five years from my almost-ten-year-old self. I walk beside that girl, soaking in the hum of a father reading to his toddler, friend-to-friend whispers, the concentration of a sun-framed teenager in a window seat, absently twirling her hair and turning pages. We look for the boy's portrait, but it's not above the dark wood staircase; there are no stairs in this library. John Deere Webber watched over my library then. He could not have stayed behind.

Ah, there—eye level between the stacks and the circulation desk, he watches still. He wears a serious yet open expression and, but for his crushy blue jacket, would not stand out in appearance. Except for his eyes. They search somewhere beyond view. You cannot will them to make contact. He would not want to see the truth of his fate in your eyes. No one does.

"She's on borrowed time," my dad used to say of my mom. At nine years of age, I prayed and bargained with God that He'd loan her some more, that her sick heart could beat strong and steady again. Like Laura, I sometimes felt scared and did not want to see far ahead. I read her books, glad she wrote her life down, all the littlest parts of it so it didn't seem so big. At nine years of age, you want to know that nothing can hurt you. Even if it does.

"There is not such a cradle of democracy upon the earth as the Free Public Library, this republic of letters, where neither rank, office, nor wealth receives the slightest consideration." ANDREW CARNEGIE

To obtain a library card at the Webber Park Library, I had only to sign my name and address without the slightest consideration of my rank, office, or wealth, which did shrink a nickel or two when I returned overdue books. I was a Girl Scout, after all.

I read hundreds of library books on borrowed time, a loan fulfilled but not paid down, a gift from a bereaved family to its heir who made us all heirs. The year 2010 marked the hundredth anniversary of their library, and now it lives on borrowed time. The Camden Webber neighborhood watches the status of a proposed new library in this, the second century of its continuous operation. The boy watches, too. He will not be left behind.

Some things can't be. My mom and I both survived my childhood, and I've survived her, though not all of her legacy. I never have wrapped my head in toilet paper, but I have smoked (for cripes sake, I quit), and I do sing every song on the radio out loud, even when I don't know the words. I have lived a lot of life now and have even written some of it down in books for children. I write to the girl I was in 1963 before the caissons of black, the nine-year-old girl who watched TV in black and white, who took pictures in black and white, who lived in a world that could only think about black and white in black and white. But the truth of that time shimmers on the fringe of memory in other colors—orange and white, red and cream, yellow and green—the colors of those days when nothing could hurt us while we were there. 🏛

ABOVE St. Bonifacius Library, Hennepin County

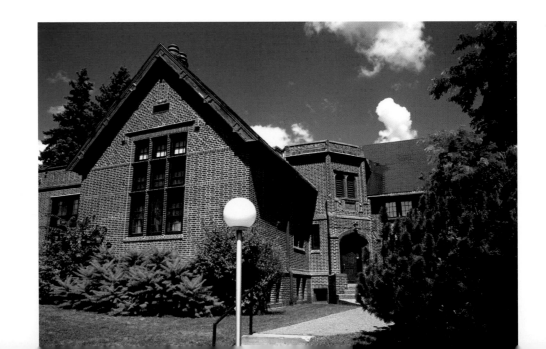

LEFT, TOP Elbow Lake Thorson Memorial Library, Grant County

LEFT, BOTTOM Sumner Library, Minneapolis, Hennepin County

BELOW Ortonville Public Library, Big Stone County

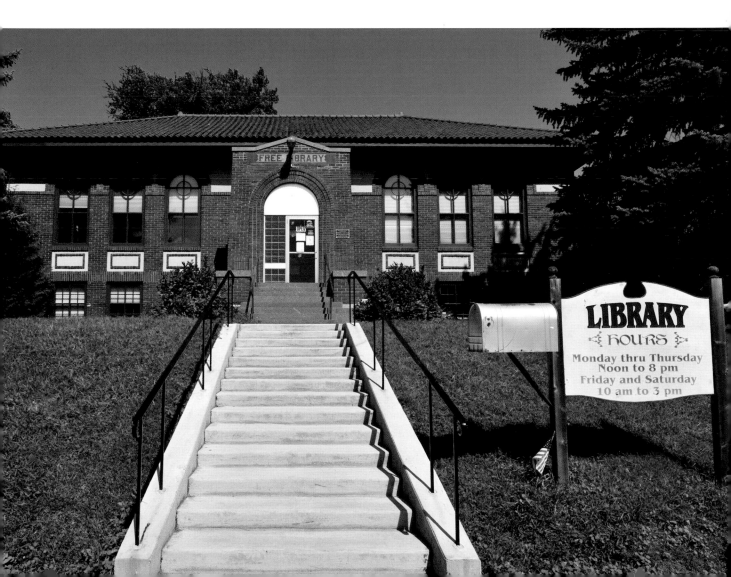

ABOVE Eden Prairie Library, Hennepin County

RIGHT Pierre Bottineau Library, Minneapolis, Hennepin County

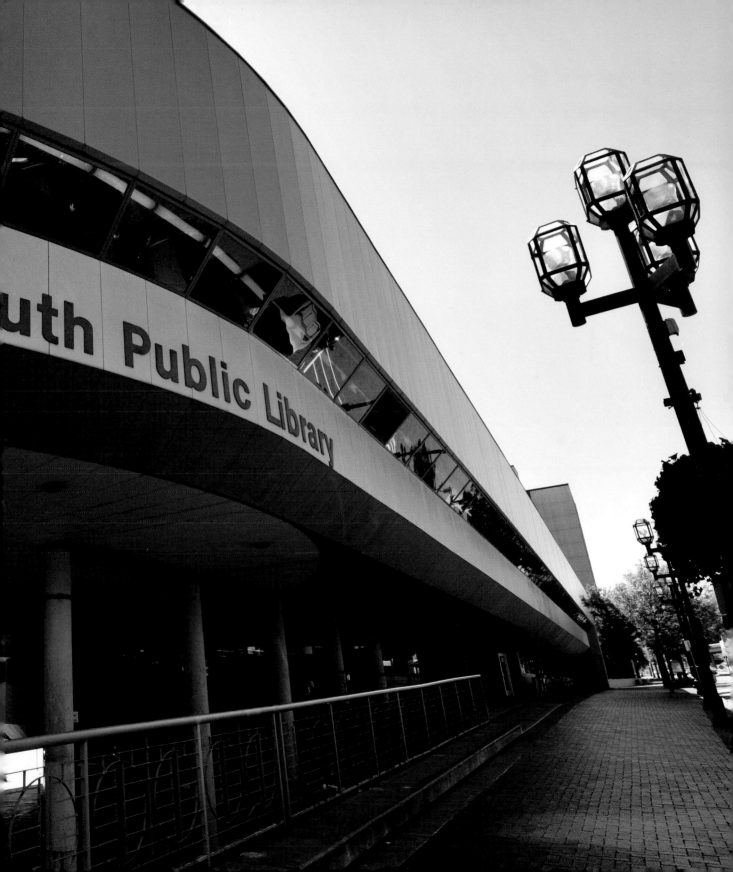

BELOW Roseville Library, Ramsey County

Meet at the

MARC BROWN · ARTHUR'S READING · EASY READ

MILDRED D. TAYLOR · Roll of Thunder, Hear My Cry

PAULA DANZIGER · AMBER BROWN IS FEELING BLUE

WO

reader!

you are a Kenyan Child

David
LaRochelle

Summer
of the Giant
Tarantulas

It was the first week of summer vacation, and I was terrified. I was twelve years old and starting junior high in the fall. Everyone knew what junior high meant: drug-crazed teenagers who stuffed you into lockers, razor-sharp band saws in shop class that chewed off your fingers, and the ultimate in adolescent humiliation, group showers. Junior high was a guaranteed death sentence, especially for an awkward sissy-boy like me.

As I climbed the wide staircase to the children's section of our county library in Blaine, I wondered why my parents couldn't enroll me in a correspondence school instead. Or maybe my dad could apply for a construction job overseas. There must be plenty of countries where junior high didn't exist.

My fears about the coming school year came to an abrupt halt when I reached the top of the stairs. Stretching in front of me was a huge treasure map filling an entire wall of the library. Winding across the map was a dotted path that led past poisonous snakes, man-eating plants, and buried skeletons. The path ended at a blood red X and an open chest overflowing with aluminum foil coins. At the top, a banner in Old English lettering proclaimed the theme for this year's summer reading club: The Pirate's Treasure Hunt.

Worries about junior high vanished. Thoughts about moving overseas disappeared. Stand back, everyone; sign me up for summer reading!

I was no stranger to the summer reading club. My scrapbook held a collection of previous years' reading logs. Forty years later I still have those cardboard folders, their covers emblazoned with shiny foil stars, one for each book I had read. But the summer reading club of 1973 and the gigan-

tic treasure map promised something even more exciting than a handful of gummed stickers.

A librarian in a flowered muumuu cheerfully explained the rules: "The more books you read, the farther you'll move along the path. Fill your chart and you'll reach the treasure."

The skin on my arms tingled with excitement.

She handed me my reading chart. On the first of fifty numbered lines I wrote the title of the book I had finished last night, *From the Mixed-Up Files of Mrs. Basil E. Frankweiler.* I handed it back and she wrote my name on a tiny paper pirate, which

ABOVE Chatfield Public Library, Fillmore County

she pinned to the first landmark on the map: Walking the Plank.

"You're on your way," she told me.

Arrrgh, Matey! Indeed I was!

The summer reading club lasted ten weeks. I needed fifty books to fill my chart. Could I do it? You bet. In fact, I was going to be the first pirate to reach that chest.

The next seven days were summer bliss. Reading at the picnic table with a handful of Oreos and a glass of Kool-Aid. Reading in the hammock beneath our apple tree. Reading on my beanbag chair inches away from our family's rattling box

fan. Each book I read brought me closer to the treasure. Not only that, as long as I kept focused on the adventures of Pecos Bill and the Patchwork Girl of Oz, my worries about junior high stayed at a manageable distance.

A week later I returned, clutching a long list of books. The library's icy air conditioning embraced me as I bounded up the stairs to the second floor. The cheerful librarian in her purple muumuu was waiting at the children's desk. She handed me my reading chart and I counted ahead a dozen spaces. Twelve new titles took me past the Quicksand Pit and the Crocodile Swamp and all the way to the Buzzards' Cliff. What an adventurous reader I was! At this rate, I'd be at the treasure in no time.

I smoothed out my list of books and began copying.

"Remember," said the librarian, "only two books per visit."

My pencil froze. Two books? But I had read twelve!

"We don't want anyone rushing through the game," she added. "Do we?"

As a matter of fact, yes, we did. *I* wanted to rush through the game. *I* wanted to be the first at that chest. At two books per visit, how would I ever reach the treasure?

Too obedient to question authority, I reluctantly picked out my two favorite titles and wrote them down. The librarian moved my pirate ahead two spaces to the top of Spy Glass Hill. So much for being an adventurous reader.

With a two-books-per-visit limit, I needed a new strategy if I was going to reach the treasure. I needed rapid-fire visits to the library. Unfortunately, I lived too far away to bike there on my own, so I was at the mercy of my parents to provide transportation.

"Can we go to the library?"

"Not now, I'm in the middle of washing clothes."

"Can we go to the library?"

"I thought your father asked you to mow the lawn."

"Can we go to the library?"

"It's such a beautiful day. Why don't you play outside instead?"

Blackbeard himself never faced the obstacles I did.

Finally, at the end of the week, my father caved in and drove me across town.

"Take your time," he told me, settling into one of the library's cushioned chairs with a copy of the *Minneapolis Star*. "I'll be right here."

There was no one at the children's desk to

record my reading progress, so while I waited for someone to show up, I wandered.

First I explored the nonfiction shelves. Boys at school devoured books about dirt bikes and WWII army tanks, but I preferred the craft books that showed how to make Christmas ornaments out of pipe cleaners and empty wooden spools. Next I took a nostalgic walk past the picture book aisles. No one was watching, so I flipped through the pages of one of my favorite Dr. Seuss titles. So what if I was almost thirteen years old? I still liked the sound of his words. Finally I headed to the "older juvenile" section; the privacy of the public

97

library allowed me to check out the novels that I *really* wanted (*Taffy and Melissa Molasses, Snowbound with Betsy*) without being teased by my classmates for reading "girlie books."

The only section of the library that held no appeal was the adult fiction—tall, dark alleys lined with thick books that had dull titles and no pictures. Would I really be interested in those books someday? I didn't think so.

As I added another book of folktales to my arms, a familiar sound caught my ear. I looked over the second-floor railing down to where I had left my father. Sure enough, his head was tilted over the back of his chair, the newspaper was lying crumpled in his lap, and he was snoring like a Harley. It was time to head home.

The regular children's librarian was still nowhere to be seen, but one of the reference librarians was passing by. She retrieved my chart from its file and I added two titles, then she moved my pirate ahead to the Hangman's Tree. The treasure chest still loomed miles ahead. Even worse, half a dozen pirates had already passed the midway point. How was that possible? Did these kids live at the library? Did they camp out on the lawn, rushing in and out every time they finished a new book?

Before returning downstairs, the reference librarian looked at me over the top of her glasses. "You know, if you really want to reach the treasure, you should try reading more than two books a week."

My heart did a somersault. "You mean there's no limit?"

"Of course not," she said.

Shiver me timbers! I was back in the game! My arms loaded with books, I woke my dad so I could

ABOVE Hardwood Creek Branch Library, Forest Lake, Washington County

RIGHT Dawson Public Library, Lac qui Parle County

hurry home and start reading, eager to return the following week . . .

. . . where the regular children's librarian was waiting at her desk. "Two books per visit!" she reminded me.

That's how the summer went. Mostly my progress was kept to a snail's pace, but occasionally I'd snag someone who let me record unlimited books. Then I would zoom down the path, bravely making my way past haunted caves and bloodthirsty bats. All right, so I wouldn't be the first to the treasure, but I was determined to get there anyway, if only the summer lasted long enough.

But signs of the impending school year began to appear: a school physical (please let the doctor find a rare but nonlethal disease that would excuse me from gym class indefinitely), buying school supplies (only the least conspicuous col-

ors for my notebooks, nothing that would draw attention to myself), shopping for clothes with my mother (eye surgery with a pickax would have been less torturous).

And all the while I kept reading. Reading took me to Narnia, Sherwood Forest, and the banks of Plum Creek, exciting places where I didn't have to think about junior high.

If I had been writing my own story, the junior high would have burned down over the summer, my parents would have taken me to the library every day, and I would have finally reached the treasure. But none of those things happened. When the reading club ended, I had logged only thirty-one books, which left me stranded at the giant tarantulas.

"Thirty-one," said my mother. "That's a lot." She was driving me home from the end-of-summer

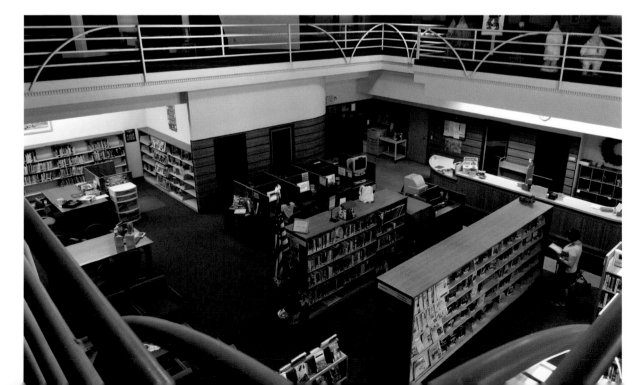

reading party at the library. Two hundred kids had been crammed into the library's humid garage, where we sat on sticky metal folding chairs and watched a movie about seals. It must have been the closest thing to a pirate film they could find.

Then she asked the question I could no longer avoid. "So, are you ready to start school?"

I wasn't, but it didn't look like I had a choice. My father hadn't ordered passports, so I guessed we weren't moving overseas.

I looked at the scowling pirate on the cover of my reading chart, which had been returned to me at the party. I scowled back. Why did summer have to end?

My mom pulled into the driveway. "I've washed your new school clothes," she told me. "I want you to try them on again before dinner so I can make sure that they still fit." She smiled. "You're going to look so cute."

She got out of the car but I stayed where I was. Worries of teenage bullies and gym class crowded back into my brain. My stomach tightened into a knot.

Then I looked at the list of books I had read over the past ten weeks: *Miss Hickory, All-of-a-kind Family, You've Come a Long Way Charlie Brown.* The knot in my stomach loosened. True, I hadn't

reached the treasure, but I *had* read a lot of good books. And reading had made me happy, even in the looming shadow of junior high.

Okay, maybe the summer reading club was over. And maybe I was going to face something worse than giant tarantulas: ninth graders. But no matter what happened, the library was still going to be there, and nobody, not even a drug-crazed ninth grader, could stop me from reading the books that I loved. Books that made me happy even during a terrifying summer. Books that showed me examples of bravery and gave me hope. If Laura Ingalls could face a swarm of locusts, maybe I could face shop class. Or, better yet, like the children in *Half Magic,* maybe I'd find an ancient enchanted wishing coin. Then I could send my junior high to the far side of the moon. The library and all its books had gotten me through the summer, and maybe they'd get me through the school year, too.

I took a deep breath and got out of the car. Bravely I went inside to try on my school clothes. Then I asked, "When can we go to the library again?" 🏛

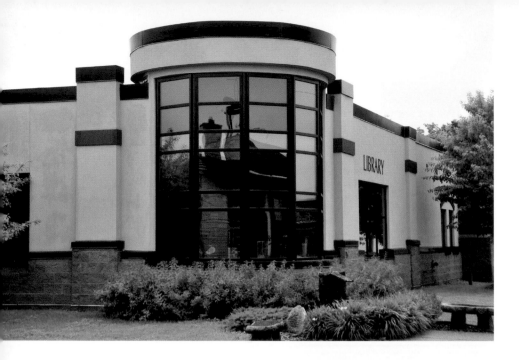

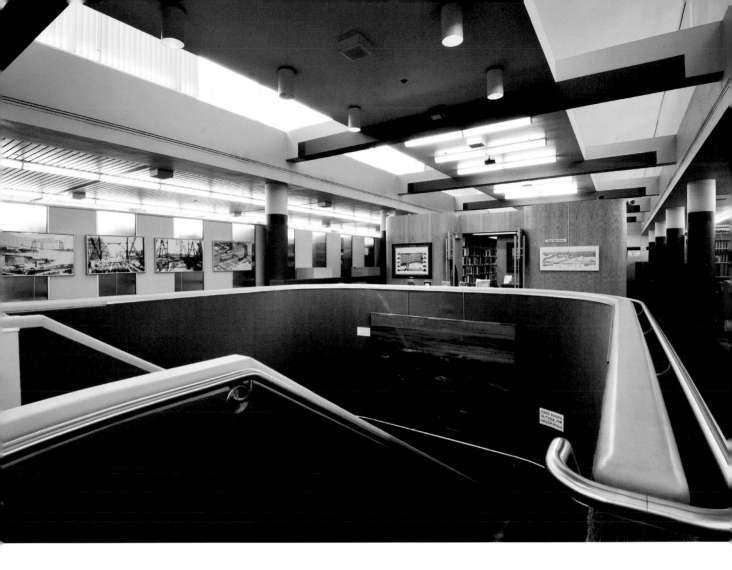

LEFT, TOP Annandale Public Library, Wright County

LEFT, BOTTOM Roseau Public Library, Roseau County

ABOVE Duluth Public Library, St. Louis County

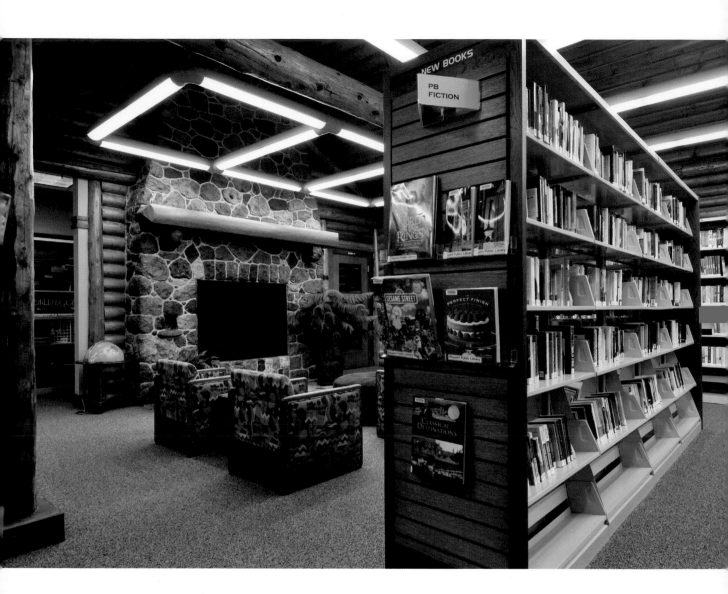

ABOVE Bayport Public Library, Washington County

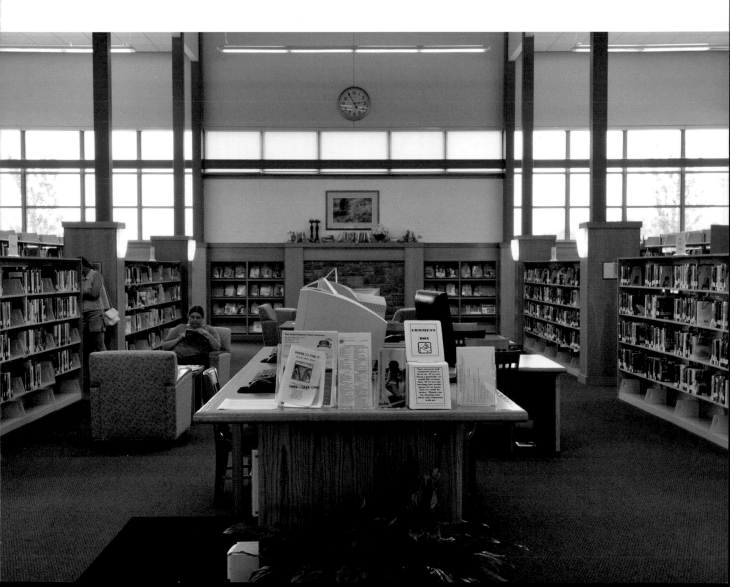

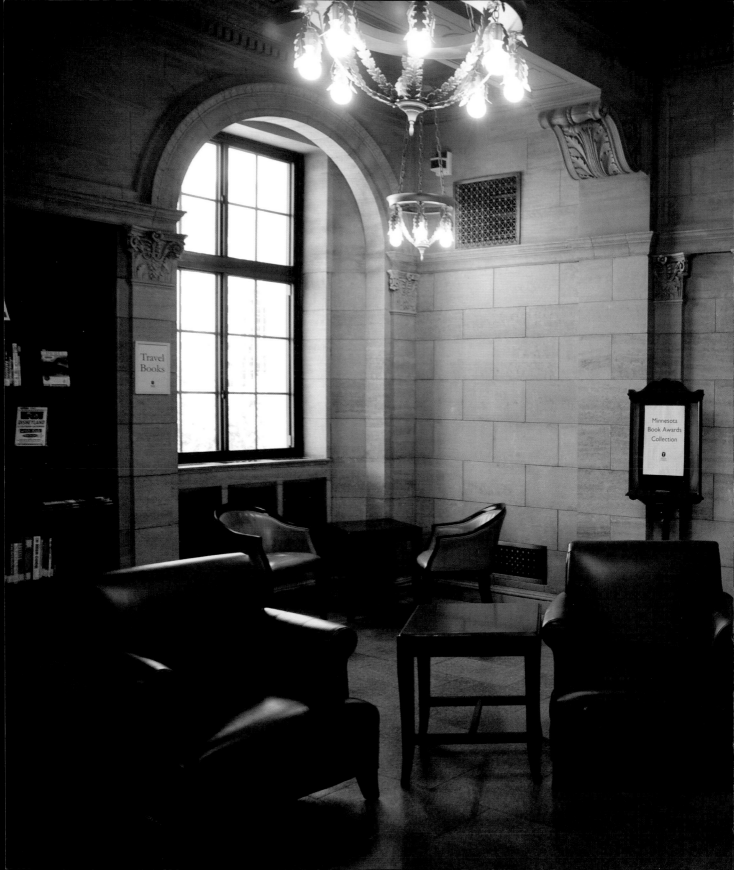

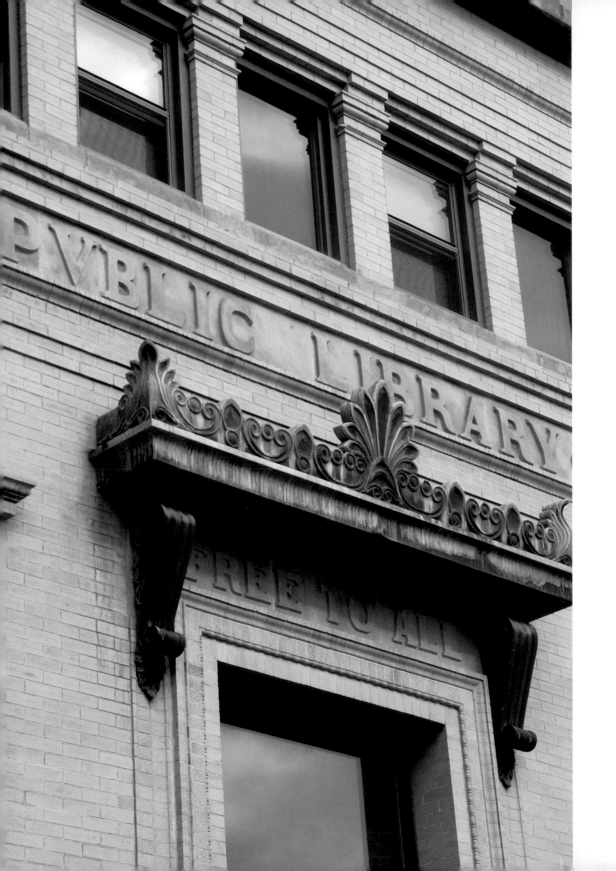

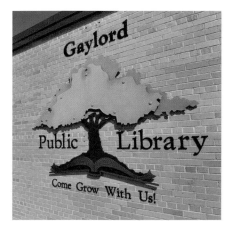

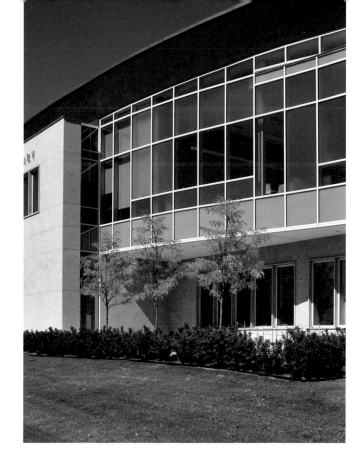

LEFT Owatonna Public Library, Steele County

ABOVE Gaylord Public Library, Sibley County

RIGHT St. Cloud Public Library, Stearns County

BELOW Sauk Centre Public Library, Stearns County

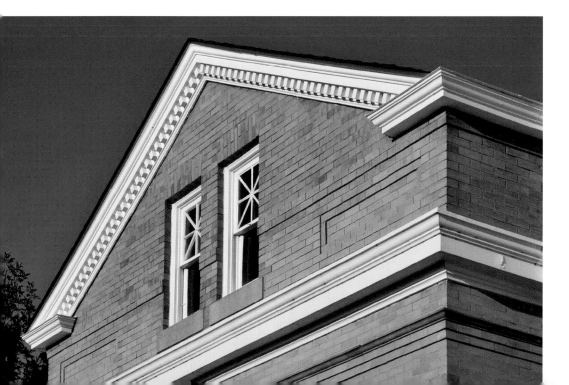

Kao
Kalia
Yang

Invisible
Stories

Part I

On the good days, her father took her and her sister to the St. Paul public libraries. They had two favorite ones: the Rice Street branch before it got the fancy wall of windows on its busy road, with businesses and houses and schools all mixed and matched, and the one called Arlington Hills, on its quiet rise where the trees were older and the

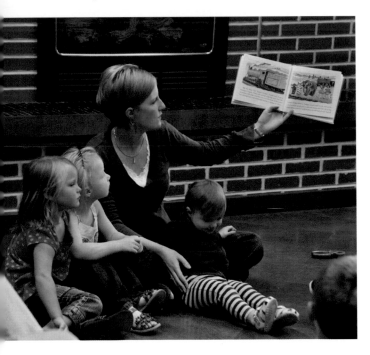

boards of the houses sagged, drooping on the old frames, paint peeling.

The family didn't have much money. They didn't have a VCR in their house, or CD players, or cable television. The sisters borrowed books with their purple library cards, and the family in the house had many stories to share. Her mother talked about the noises from the machines at work, the growl and the ceaseless hunger of their steely mouths as pieces of engine parts traveled in and out. Her father told about the adventures of their smoking Subaru. Everywhere the little brown car went, fumes of smoke ballooned into the air and puffs of dark clouds rose into the sky from its shaky muffler. The girls opened up their books, and they traveled to long-ago China, where houses were on stilts, and faraway Vietnam, where an emperor sat by a pool to pick at lotus blossoms. Sometimes, they visited the corseted ladies of cold England, other times looked for pigtailed little girls who knew firsthand the smell of apple pies in the buzz of summer insects in the heated air. The different stories met in the tiny dining room and living room and bedroom, and everybody felt that the house was a rich garden full of flowers borne in worlds blossoming.

Sometimes, the older girl read to the younger

PREVIOUS PAGES Maplewood Library, Ramsey County; Austin Public Library, Mower County (inset)

ABOVE Roseau Public Library, Roseau County

one and their baby brother and sisters. She had lovely, tan hands. As she read from the books, taking on different accents and tones, her little sister imagined what marvels her sister's hands could perform one day. She would do wonderful things with her hands despite their small size, the fragility of bones, the arch of a bony hill on her wrist. Her fingers were straight, and her nails were never long, and although she had just become a teenager, her personality and her big-sister attitude made her quite old already, and the way she turned the pages of a book while holding it up so the pictures could be shared was ever so gentle. The dry pages rustled only a little, a tiny window opened with each flip of a page, and a whole life unfolded. Her hands were a story waiting to happen. The books she read from were a canvas for the paint of their imaginations.

The younger sister was a shorter girl, and she couldn't reach very high on the library shelves, and she had no voice in English to ask for help. She spent much of her time spying for the stepping stool in the libraries. She felt silly and small. But brave and courageous, too, because each time she found the stool she helped herself climb higher up into the world of stories.

She did not know, all those years of reaching, that one day she would reach for her family's story.

Part II

He was known as the Library Visitor. He was my uncle's son and my first cousin. A young man with a wife and children, he'd spent most of his childhood years in the jungles of Laos during the 1970s, fleeing from the ends of a war the world didn't know happened. In the refugee camps of Thailand, he was old enough to hear the desperation of our wait, and he made promises to keep desperation away.

He said he would become a scholar.

For a people new to what is written, the idea of a son who would be a scholar, hold in his hands the words of a bigger world, was enchanting for the adults, who felt themselves too old already for a world moving in languages they could not speak.

LEFT Merriam Park Library, St. Paul, Ramsey County

113

When we first came to America, we lived with the Library Visitor and his wife in the McDonough Housing Project in St. Paul. He went to high school while she stayed home with their children. His wife was a beautiful young woman who carried tremendous respect for the potentials of an unknown scholar. Her favorite English word was *shit*. Except she never used it as a bad word—it was an exclamation of her emotions for the life in America: loud and foggy, like a noise from an unknown distance permeating the fabric of her Hmong. She spent much of her time cooking huge after-school meals for him. Her long black hair pulled up and piled high with hair spray; her long nails the color of dried blood; their cherubic children like the Asian kids on produce posters, round and soft, looking as if they were the fruits of a bountiful earth. In their home, there were many moments when I felt my sister and I were also the coming harvests of some faraway, unseen season. His harvest, though, we could already begin to see.

The Library Visitor drove a gray two-door Subaru. In the trunk he carried lots of textbooks with lots of words and numbers. There was a shovel for the cold of winter and the white mud that packed itself hard against the earth and forced a reckoning of metal before it would give. Then there was a cardboard box without a top or a bottom, just a cut along the seam of one corner—his library shield.

The Library Visitor talked of his library shield often. He would go to the public libraries to study. He would find a nice, hard table. He'd sit by himself with the library shield around him. He would open up his textbooks and study ("What do you study?" "Words, little Kalia. Words like *calculus*"). He studied all the time. He studied for long periods of time. He studied all the first years of America away. Sheltered by his library shield, in the public libraries he never went to the shelves, never checked out the books, just sat with school texts.

ABOVE Columbia Heights Public Library, Anoka County

RIGHT, TOP Owatonna Public Library, Steele County

RIGHT, BOTTOM Roseau Public Library, Roseau County

He graduated from high school. He graduated from Lakewood Community College. He transferred to the University of Minnesota.

That year, there were heavy floods. The Mississippi grew so wide, it turned the landing place of St. Paul planes into a slate of gray water. From Indian Mounds Park, the eyes of a child could see how trains could drive themselves into the heavy current of a flowing river and turn into ships on their way to the ocean, carry mermaids and maidens alike far away to a life hidden. The world had grown enchanted.

The Library Visitor didn't notice the flood at all. He hadn't noticed that the rains had fallen so heavy or long. He hadn't noticed that the grass was unreasonably tall and the trees unseasonably green. One day, his head started hurting. He looked up, and he didn't recognize what the world had become. The little kids had gotten bigger. All of a sudden, he wasn't the only one in college anymore. All of a sudden, the library shield had become a silly invention that had kept him too hidden from the world.

Part III

My little brother believes that people are alive only because we live in each other's eyes.

When he was two years old, he looked at our father, saw his reflection shining, and asked, "Why am I in your eyes?"

Our father said, "You are in my eyes because long before you were born, I was looking at the world for the both of us. And although you are only a little boy, you are looking at the world for a little boy and a little girl who will one day come along."

I keep forgetting that the things I've seen, my

of spines, slow down and quicken again, till she says, "Stop."

I will look at her, and I will say, "Is this your story today?"

And I will not know what her answer will be. But I will understand that such is the nature of libraries and books, of lives: we take on stories and we live through them—in the moments that comprise our days, in the memories that feed into and strengthen our imaginative holds.

Across from each other, or perhaps along the same edge of the table, we will sit, skin touching. Our hands will reach for the covers of books. Together, we will turn the pages of our lives and lives far away and make believe: that the world we belong to has always been older than we are and the worlds we are traveling toward far more vibrant and beautiful than we can possibly imagine. We will create and carve out belonging with our curiosity and our care. We will talk through the ages of belonging to each other, to ourselves. In words, letter by letter, sound by sound, we will spell out the big story that we all come from: love.

Once upon a time, love was born in a tiny little bundle of blood and skin, muscle and bone, cells and molecules. Love carried no name, no face, no particular form. It was a period at the end of a

children will see reflected in me. I keep forgetting that the stories I've lived in, my children will live in through me. I understand that our stories do not have to be found on library shelves in order for us to live in them. And so I write of invisible stories. I write of the stories in my life. I write of the stories coming to theirs.

116

Once upon a time, a little girl or a little boy will be born into the world. Maybe it will be a girl and she will carry a name that we don't quite know of yet. She will have straight black hair or curly brown hair with tints of amber or perhaps of a setting sun that carries the light of early dawn. Her tiny hand in mine, we will journey our way to the libraries.

On stools, I will climb to reach the places she can't get to. My fingers will trace along the curve

sentence. The first flow of ink on paper. It was a stream of time flooding at the gates of wonder. It was a string of light, flexible and glowing. It was a spark of life emerging from the unknown. It was an explosion of life into the waiting possibility. Once upon a time, love was born in a tiny little bundle of blood and skin, muscle and bone, cells and molecules.

Love lived in stories.

Love traveled in memories.

Love was stored in libraries. 🏛

ABOVE Maplewood Library, Ramsey County

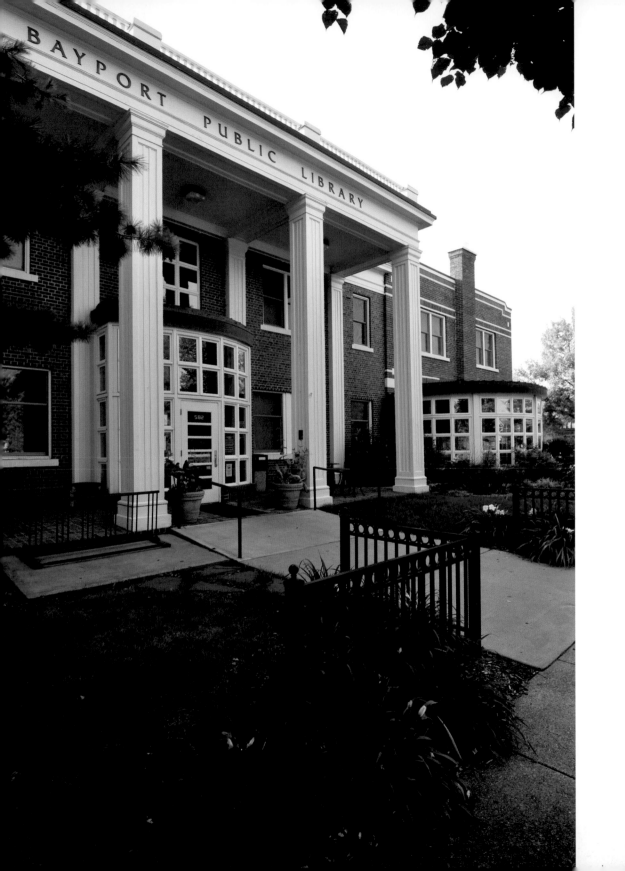

LEFT Bayport Public Library, Washington County

BELOW Dyckman Free Library, Sleepy Eye, Brown County

NEXT PAGES Henderson Public Library, Sibley County

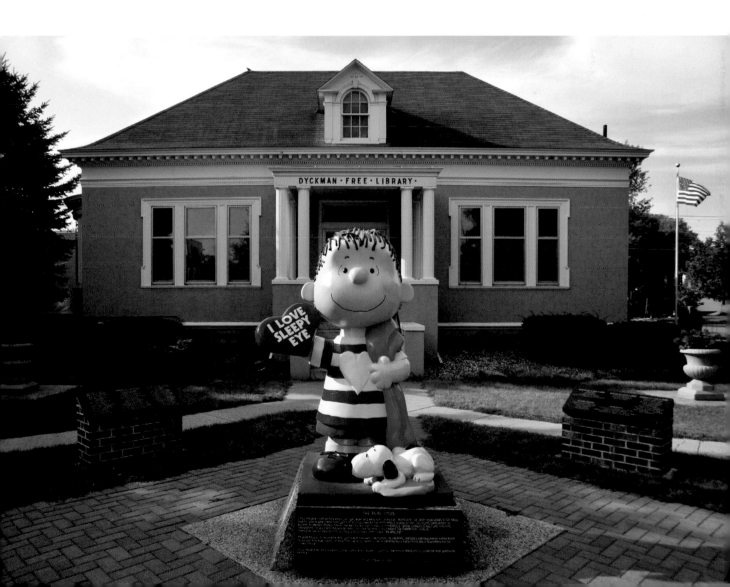

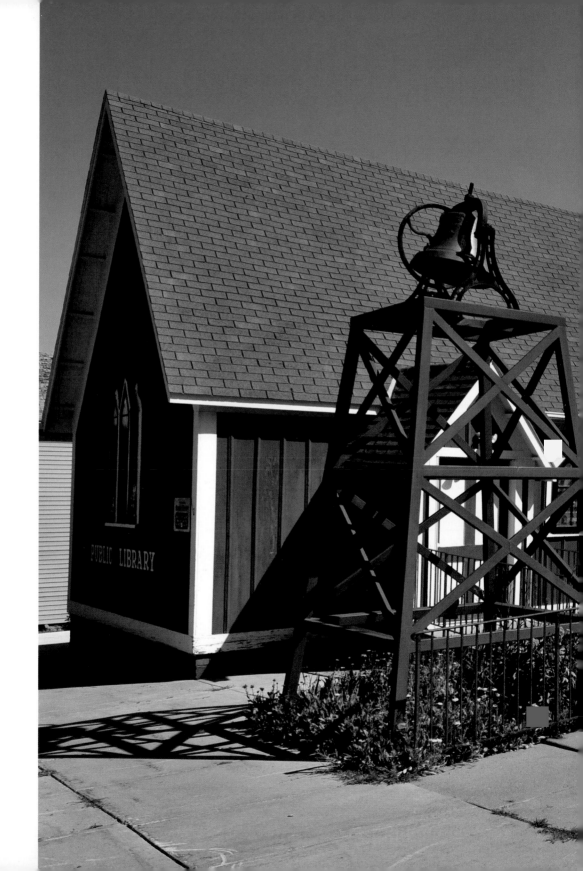

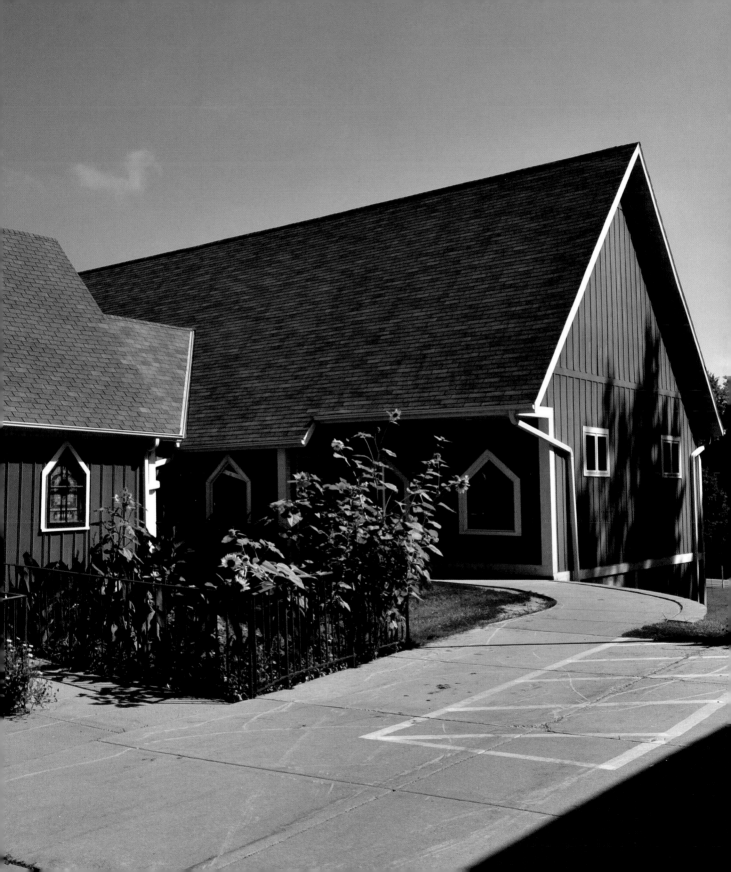

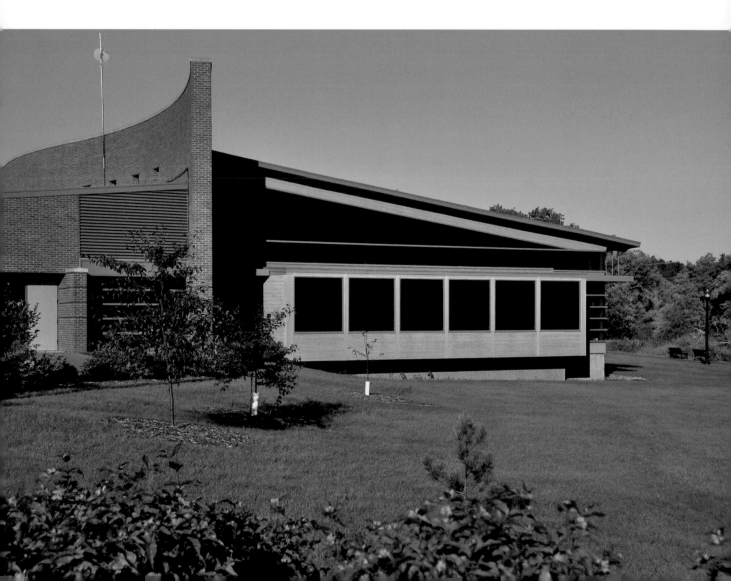

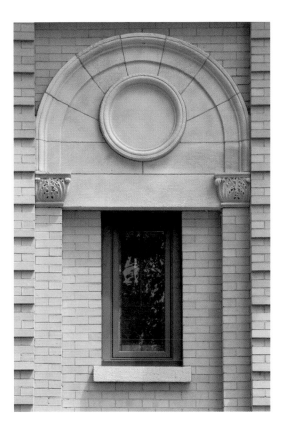

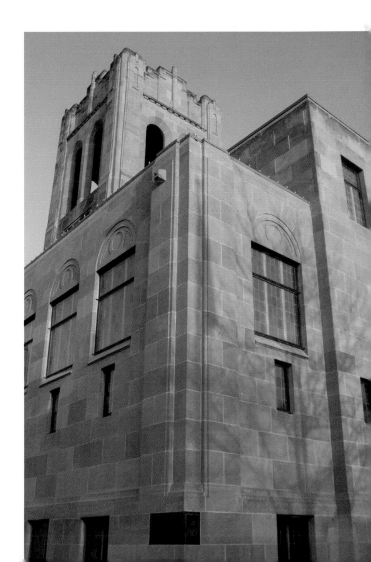

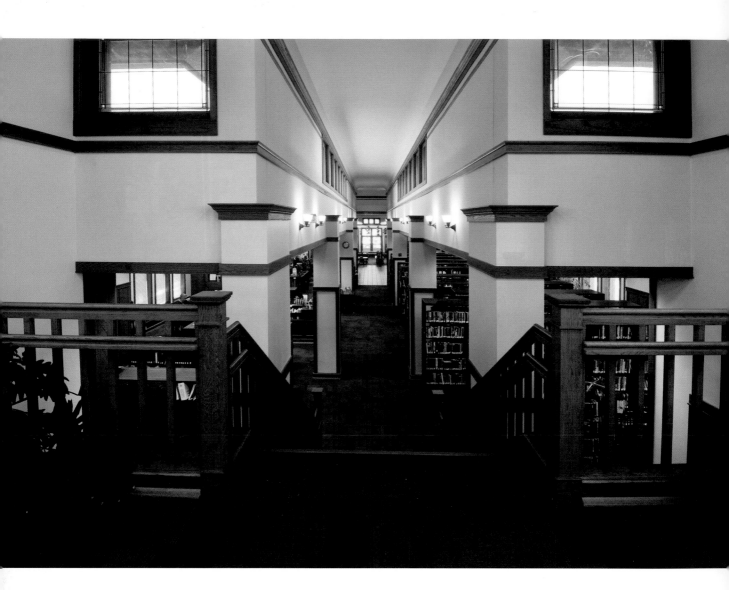

ABOVE Detroit Lakes Library, Becker County

RIGHT Newport Branch Library, Washington County

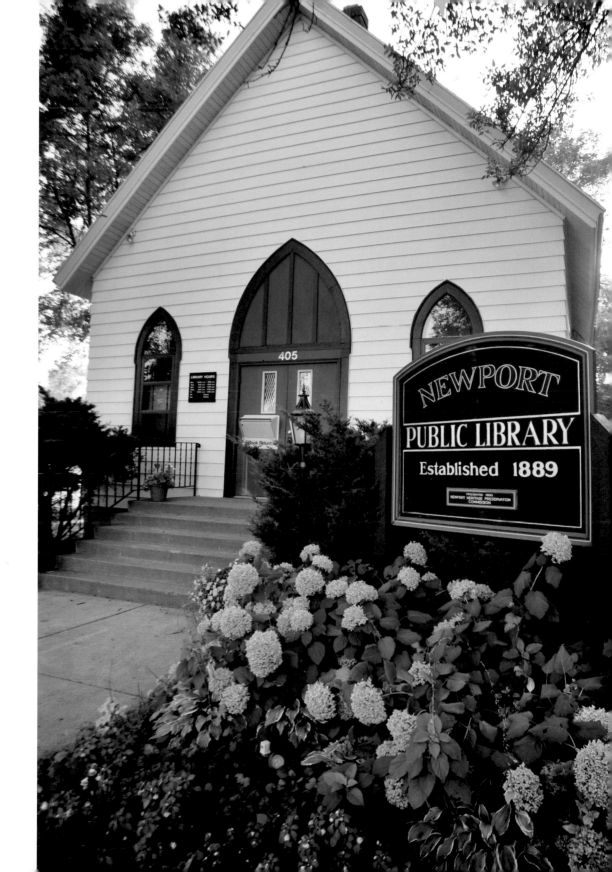

Photographer's Note

When I was six, before I could sign up for my first library card, my parents required that I memorize my address and phone number, which I still remember today. Then I climbed the massive steps and stepped through the four-column portico into a world of adventure. I will never forget the sights, smells, and sounds (or lack thereof) of the old Anoka Carnegie. I don't recall the titles of the first books I checked out, but I do remember how excited and slightly nervous I was as I waited to show the librarian my new paper card. I still love the sense of reverence that washes over me as I step into these community treasures.

Photographing nearly seventy libraries throughout the state, I was privileged to observe the important role they play in community life. Some of the old buildings have been put to new uses, dramatically remodeled, or replaced with state-of-the-art facilities. Each of the structures was interesting and unique, but what I enjoyed most was trying to capture the life of the library: a young boy lost in the detective world of the Hardy Boys, a mother reading a pop-up book to a small group of neighborhood kids, a recent immigrant using the library computers to learn English. These everyday scenes make this *Minnesota Byways* book different from the others in the series, and I hope it will remind you just how

important our libraries are to the health of our towns and neighborhoods.

I recognize and thank the Council of Regional Public Library System Administrators and Ann Regan of the Minnesota Historical Society Press for having the vision to showcase Minnesota libraries. I am honored to share the stage with some of Minnesota's best-known writers as we celebrate our libraries. Special thanks to all the librarians and support staff who allowed me access to their buildings. Finally and always, I appreciate the ongoing support of my wife Krin, daughter Emily, and son Matt.

DOUG OHMAN
New Hope, Minnesota

126

ABOVE Detroit Lakes Library, Becker County

List of Libraries by County